EDWARD BURRA

A Painter Remembered by His Friends

EDWARD BURRA

A Painter Remembered by His Friends

John Aiken
Mary Augusta Aiken
Frederick Ashton
John Banting
William Chappell
Gerald, Desmond and Phyl Corcoran
Clover de Pertinez
Ninette de Valois
Barbara Ker-Seymer
Anne Ritchie
John Rothenstein

Edited by
WILLIAM CHAPPELL

Foreword by
GEORGE MELLY

ANDRE DEUTSCH
In association with
The Lefevre Gallery

First Published 1982 by
André Deutsch Limited
105 Great Russell Street W.C.1

Printed in Great Britain by
W. S. Cowell Ltd
Butter Market
Ipswich

ISBN 0 233 97450 4

Contents

LIST OF COLOUR PLATES

LIST OF ILLUSTRATIONS IN BLACK AND WHITE

EDWARD BURRA

A Painter Remembered by His Friends

Foreword

GEORGE MELLY

WHEN WILLIAM CHAPPELL, the editor and major contributor to this book, approached me at Burra's memorial exhibition at the Lefevre Gallery and asked if I would write a foreword, I was both extremely touched and at the same time rather intimidated. I had become a friend of Edward's only towards the end of his life whereas all the other contributors had known him for much of it, while Chappell himself had been close to him from his schooldays until his sad but courageous death. After some thought, however, I realized that perhaps this put me in an ideal position to act as prologue. I can remember so clearly the frail but determined old painter, can hear at will that selfmade Cockney drawl like an elderly but game Edwardian tart propositioning from the shadows, yet at the same time I have only the broadest outlines of his early and middle years; a handful of famous anecdotes, a few characteristic comments, a small selection of those inimitable ill-spelt, unpunctuated letters and postcards. I believe therefore that I can act as a bridge between those who knew him personally and well and those who know him only through his work; to raise the curtain on that uniquely odd, much-missed sum of contradictions, that sociable recluse, that endlessly diverted observer of human nature at its most suspect, that great artist Edward Burra.

The twelve memoirs which follow are of a value beyond their affectionate intentions. They remind me of those personal recollections which appear in *The Times* some days after the official obituary and frequently succeed in evoking the dead as they lived and breathed with a freshness and immediacy denied to those who compose the more formal obsequies.

Where to start? Perhaps with my own memories of our encounters for, although few, they are I believe characteristic and may act as a sketch for the more solid and detailed portraits to follow. I must confess I have recorded some of them before, namely as a preface to the catalogue of that same exhibition where William Chappell first approached me, but few keep catalogues and many more won't have seen it anyway. Here then is Edward as I remember him; the face with its sharp small features and network of fine lines, the hair whispy and approximately combed, the teeth a disaster area, the eyes alert and yet curiously abstracted, the

arthritic hand, that unlikely instrument of so much precise beauty, wrapped around a glass which would have fallen if held between the fingers. 'Hello dearie' he said.

I had admired his work ever since, during my naval training, I had discovered it in one of the 'Penguin Modern Painters' series in the middle forties. Later, during the sixties, my wife and I had bought a picture from one of his bi-annual exhibitions; a fierce red railway cutting penetrating a rolling feminine landscape. Even so I was apprehensive of our meeting. I'd heard he could be dismissive if he didn't take to you. Happily in my case he did.

It was the painter John Banting who was responsible (and if I have one regret about this book it is that John, being dead before its conception, is therefore represented only by a note on Burra as a painter, rather than by an extended memory of him as a friend). John lived in Hastings not all that far from Ed's cottage in his much-mocked Rye. As old friends with a shared taste for pub-crawls and dubious company, they met at least once a fortnight to roam Hastings' 'Old Town', then a nest of hippies and a source of 'pot' for which, characteristically, Edward had developed a mischievous late fondness. Age had done nothing to curb his nonconformity.

Edward had always been the more considerable painter even before drink had destroyed Banting's real if limited talent, but this made no difference to their relationship because both of them detested 'art' as a topic of conversation. I remember the curious contrast they presented: John, large and shambling with his noble battered face, Ed, small and with the neat economical gestures of someone who had to preserve his strength. At our first meeting there was also John's live-in friend, an ex-Glaswegian docker incoherent on Haig, and my companion, a girl dressed in blue denim blazing with real diamond butterflies. Our destination was a club attached to a caravan park where I was to sing and which John, who had accompanied me there before, thought Ed would appreciate.

Even before we left John's squalid but idiosyncratic flat with its writhing plant-life and its pictures hung on string so coated with dust that for a long time I took it to be rope, I had noticed something about Edward Burra which closer acquaintance was only to confirm; his ability to claim and transform everything and everybody about him. All of us seemed to become figments of his imagination, metamorphosized into Burra people, and the caravan club was to reinforce this impression.

It was a low brick building divided into a garish jazz room and an adjoining 'family room' where sing-songs took place led by a large lady called 'Auntie Mae'. The clientele, dressed up to the nines, were prosperous East-Enders who looked as though they'd done well in scrap metal or second-hand cars, and they exuded a slightly dodgy bonhomie. Edward

had always like jazz; his paintings of Harlem in the thirties are among his finest work while his description of the Savoy Ballroom in a letter to Barbara Ker-Seymer, one of the contributors to this book, is a little master-piece of succinct observation. It was however the interval which really drew him out.

We had wandered into the 'family room' where Auntie Mae was oblig-ing with her version of 'Pack Up Your Troubles' sung in a loud if tuneless contralto. When she reached the line 'What's the use of worrying. It never was worth while', Edward turned to us and hissed 'It never was, dearie!' a comment open to several ambiguous interpretations. What was it he didn't think worth while? The singer? The song? Life itself? Were any of them worth while? Was anything?

Afterwards we sat drinking with the owner of the club in his ruffled evening shirt, and his wife, a plump lady in her middle years who com-plained that Biba's, the now extinct department store, didn't make dresses her size. Shoes yes, so she always bought several pairs at a time.

'She wants you to notice her feet, dearie,' said Edward, adding quietly after a thoughtful pause, 'Mind you, they *are* small.' In many of his paintings the 'dainty' shoes of his formidable harpies are recorded with a precise and loving malice.

Edward obviously enjoyed his evening and agreed to repeat it on several occasions. Once I and the diamond butterfly girl went, by appointment, to pick him up in her car. We knocked at the door of his cottage and nothing happened. We knocked again. Finally a grubby curtain was raised an inch or two and an eye was revealed. The curtain was lowered. Several minutes passed. Were we to go away? Had he changed his mind? We waited uncertainly and then, just as we were about to call it a day, he appeared from the back of his cottage, greeting us with apparent surprise. It was extremely, and I believe deliberately, disconcerting.

I didn't see him much in London as he never went to his openings. He did visit me once with John Banting bearing, as a gift, a rare jazz record of Sarah Martin singing 'A Green Gal Can't Catch On'. He relished this title and repeated it, with various experimental intonations, throughout the evening. Naturally he ignored his own picture of the railway siding hang-ing in a prominent position. He must have seen it of course, but for him painting was what he was doing, never what he'd done.

When he appeared, with extreme reluctance and the minimum co-operation, in an Arts Council film, he and I were shown, at my suggestion and to his relief, visiting a drag-show in a pub on the Harrow Road. It was as tawdry as he'd hoped and he got on immediately with the artistes, none of whom had the least idea who he was. He had this knack of establishing instant rapport with strangers as long as they lacked pretension and

weren't *kunst*-struck. We drank a great deal and parted in the street outside, he apparently sober, me extremely drunk.

'Goodnight dearie. You *are* in a state,' were his parting, and for me final words. I didn't see him again before his death a year or two later. I heard that at the time of his retrospective at the Tate he formed a late friendship with Francis Bacon, and reported accounts of their progress together through clubs and pubs, made me very much regret that chance didn't land me their company.

Ahead lies much of the history of E. J. Burra recorded, from various angles, by those who knew and loved him. The most remarkable thing perhaps is how little he changed. The schoolboy sitting on the steps of his parents' kitchen-garden with the young William Chappell is basically the same person who died in hospital over five decades later. What, one can't help wondering, gave him his view of the world; a dark view later confirmed by history but still unguessed at during those warm Edwardian evenings? What trauma, to refer to Sir John Rothenstein's contribution, caused him to pin up the hideous photograph of a leper's head at the top of his father's conventional house to mark the entrance to his domain? Rothenstein suggests evil as the basis of all Edward's subject matter. I would challenge this in part. His torturers, his bullies, his soldiers, some of his phantasmagoria *are* evil, but many of his creatures are simply louche and disreputable. He loved naughtiness. He enjoyed depravity and bathed it in a glamorous eccentric light. He was acquainted with imps as well as demons.

The essays which follow reveal diverse aspects of the same man: as a designer for the stage, as an exhibitor at one gallery over a long period, as a child, as a wanderer, as a compulsive worker, as a will o' the wisp, as a miraculous survivor against all odds, as a dying man. One of the most revealing is Mary Aiken's description of Burra in America. His health as precarious as ever, he manifested his usual serendipity in finding, in every corner of that huge continent, authentic Burras before the event. From Boston to Mexico everything conspired to entrance him. Who but he could have discovered a bar-cum-dance hall called 'Izzy Orts', the subject incidently of a masterpiece which came to light comparatively recently? For Edward Burra the whole of life – whether terrible or merely bizarre, the spectrum of his vision – was a voyage of discovery, a new-found-land.

EDITOR'S NOTE

These short memoirs of Edward Burra by his friends are, of their very nature, personal and restricted: in some cases wary, in others over-affectionate. They are not definitive.

It has to be admitted that it is almost (if not quite) impossible to define the intricacies of the thought processes of a real painter, whose imagination is continually besieged by the contradictions and complexities of hundreds of external influences, mental and visual. The observer can be conscious of these, but he knows next to nothing about the silent (and usually conflicting) emotional reactions to every aspect of the world that only a painter sees with so alarmingly heightened a vision.

The exceptionally creative human lives and thinks on many more levels than the average person; and as a result carries within him many more conflicting and competing attitudes. His brain is like a bee-hive, swarming, crawling and buzzing: a hive full of workers, drones, eggs and grubs, the glittering and endlessly active mass controlled by a queen bee. Is she inspiration? Genius? Or just plain, natural instinct?

Even given endless time and all possible information (meaning perhaps a quarter of the knowledge necessary), and a great deal of intuition and patience, any study of an artist will, I fear, always be slightly blurred.

There was a reticence about himself and his work in the character of Edward Burra, stemming quite possibly from his Westmorland ancestors.

He was exuberantly explicit about his ordinary enthusiasms: food and cooking, the cinema, the music hall, the many kinds of book that he enjoyed. But about his own physical being and his painting he was a clam – he closed the perfectly fitted edges of his shell against intruders as tightly as the doors of any safe. Otherwise he revealed the warring elements of his nature without apparent awareness of them. He showed a vast intolerance of some who hardly deserved its weight, and an equally vast tolerance of others who were unworthy of his attention. His taste for low life was balanced by a thorough enjoyment of really high life. He had an inclination (often found in those brought up in comfortable middle-class surroundings) to have his own way, which was counterpointed by passivity and a willingness to do as others wished. There was a never-ending battle between his natural socialism and his inborn conservatism; and his impulsive generosity towards his friends contrasted with an apparent determination to make his own home life as uncomfortable as possible. Eventually, of course, all these conflicting tastes and impulses coalesced into his work, the dominant and passionate interest of his life. To paint was the vital necessity

of his being, yet when a painting was finished his lack of interest in it was complete and final. It seemed to cease to exist. If by any chance he had to see it again he regarded it with the eye of a stranger. 'I don't feel', he once said, 'they have anything at all to do with me.' It was not in the finished product but in the creating of it that he discovered his most fulfilling, and possibly his only true, satisfaction.

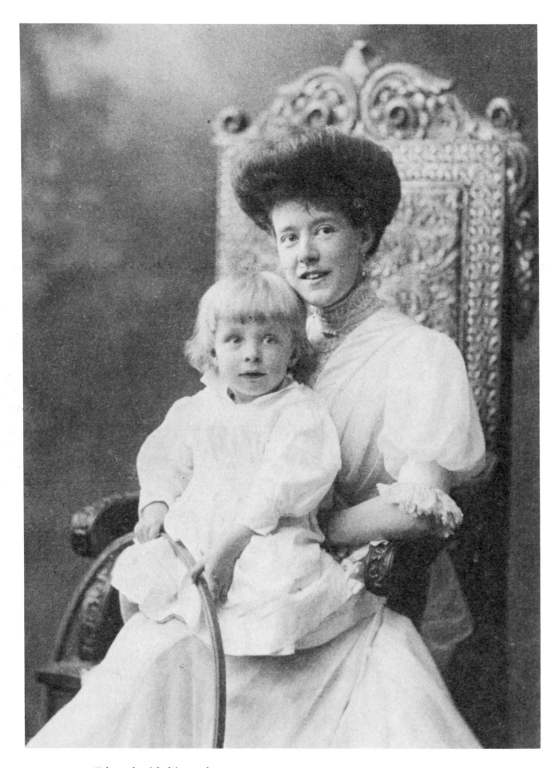

Edward with his mother

Childhood

ANNE RITCHIE

THE BURRA FAMILY came from Westmorland. They were small farmers farming their own land, and living near Maulds Meaburn, Kings Meaburn and Crosby Ravensworth.

Robert Burra was born at Crosby Ravensworth in 1742 and moved south – to Carshalton – in about 1790, to become a partner in a merchant house in Watling Street.

His eldest son returned to Westmorland (to Gate near Dent) where he, and later his descendants, lived until about 1950. William, the youngest son, my great-grandfather, joined his father's firm and must have prospered. He married a Miss Pomfret from Tenterden, and went to Tonbridge to live in a large house opposite the school, which his sons attended. He moved, eventually, to Ashford where he joined the bank of Temmet, Pomfret and Burra. His son, my grandfather, Henry Burra, left Tonbridge for the Imperial College, Haileybury as he was destined for the East India Company. He won prizes for Sanskrit and Persian. He had a very successful career in India, but had to return home in 1862 owing to the death of his mother.

He was a skilful artist and brought back many Indian sketches. In 1863 he married Frances Curteis and the following year he bought Springfield, a house in the Parish of Playden near Rye in East Sussex. Six children were born of the marriage; my father, also christened Henry, was the eldest son.

My grandfather had entered the Rye Old Bank – the Pomfret and Curteis, now Lloyds – to learn the business of banking. He became extremely active in local affairs; so much so he was finally persuaded to become Mayor of Rye. His wife died after the birth of the youngest child and her sister Miss Mary Curteis came to live at Springfield to look after the children.

My father was educated at Charterhouse and Magdalen College, Oxford. For a short time he was a barrister, but he gave that up on his marriage, and he and my mother came to live in Springfield. My mother was a Miss Ermyntrude Robertson-Luxford. Two of her grandparents were Scottish, the other two were one English and one Irish. Her childhood was spent between London, Edinburgh and Croscraig on Loch Rannoch. Her father,

J. S. O. Robertson-Luxford, inherited the Luxford family home at Sale-hurst in East Sussex on the death of his uncle in about 1895.

Mama was very musical, and studied singing in London, and when she was at school in Dresden. There, she went constantly to the opera for which she had a passion throughout her life. Dah was not musical; but he was, I would say, exceptionally well read, and had a great appreciation of pictures; I hesitate to use the word *art* for Edward so hated it; my father too, I think.

Like his own father, Dah took an active part in local affairs. He was a magistrate, and a member of every possible committee. He was for many years on the East Sussex County Council of which he finally became chairman. This would take him into Lewes every Tuesday. He invariably brought back for us sweets and biscuits from a special shop. If we were at school he never failed to send us the sweets. Whenever any one of us happened to be away from home, he wrote regularly every Sunday, detailed letters of what had been happening in our absence, always signing himself, 'yrs affectly. H. C. Burra'.

My earliest recollections of Edward go back to the time when he had a governess called Sophie Forbes, and I was still in the nursery with Nana. I must have had some lessons in the schoolroom because it was Sophie who taught me to read. We were very devoted to both nurse and governess. Sophie left us when Edward went to his prep school and I believe she was married shortly after leaving.

Edward was a very kind brother, and always let me play with him; though usually in a rather inferior role. For example, when we built our town, as we did nearly every day, I was only allowed to arrange the suburbs which were composed from six very ornate Russian houses and a box of a few simple English village homes made of cardboard. Edward would build the rest of the town and cram it with terrible tenements and glamorous theatres and cinemas.

I would follow him everywhere in the garden, even to sitting in absolute silence for an hour, hidden among the Jerusalem artichokes, so that he might avoid a Latin lesson. I can also remember meekly trying to smoke blotting paper cigarettes filled with damp leaves.

As Edward was four years older than I, he was allowed to take me about. We would go to matinées at the Rye cinema, which we loved and could not bear ever to miss because of the serials. There was a considerable amount of audience participation during the matinée performances, and the pianist would sometimes have to stop in the middle of the most exciting parts, to tell us all to shut up.

Our parents must have had absolute faith in Edward's common sense, as we were allowed to go out together when I was really very small – seven or

eight, I suppose. He would take me to the sea at Camber where we always played by a tidal creek which was shallow at low tide but deeper than me when the tide was high. On its sandy banks, inevitably, we built a town. These towns at the seaside were made from little bits of wood picked up along the high-tide mark, with the addition of small square sand-houses if we could not find enough wood. It was especially exciting if the tide was coming in, because then we could watch it all being washed away. When we built towns at home we used to darken the room and then bomb them. It fascinated us to see what was left standing after a raid. Incidentally, all breakable inhabitants were removed to safety before the bombing began.

A toy theatre was another very enjoyable plaything. It possessed an indoor and an outdoor scene, but Edward had his own ideas and designed some other, and quite different, sets. He and Dah made the scenery and cut out actors for *The Bluebird*, which I thought the most beautiful thing I had ever seen. Sometimes I was allowed to work the trapdoor and to raise and lower the curtain. The lighting was simple: old candle-ends.

Another pleasant pastime invented by Dah was to make houses from old Gold Flake boxes (he smoked endlessly) with cut-out windows and doors. We would put lighted spills inside them and wait for a holocaust of flames to come through the apertures.

In the holidays our cousins Billy and Frankie Broderick and their parents came to stay with Aunt Denny, who lived opposite Springfield. We were constantly in each other's company, going for bicycle rides and picnics and playing every sort of game in our garden. On wet days we played on roller-coasters in the drill shed,* or the boys would play billiards, for which I was too small so that some special game would be invented for me. In the winter our parents, aunts and uncles would play cards with us, but that bored Edward. There was a game called Loo during which the expression 'Loo or take Miss' was used. Edward found this very funny and used it in every game regardless, turning the whole thing into a hopeless joke.

A part of every holiday was spent at our grandparents' house in Salehurst. Two other cousins, Lawrence and Sheila Rich, would also come to stay with Grandma. Edward and Lawrence were tremendous friends and would always build an elaborate town resembling Monte Carlo on an island in the centre of a shallow ornamental pond. They each had a toy liner about eighteen inches long, and a fleet of smaller boats. The towns were ruled by two strange women called the Dilly Sisters (Phyllis and Gladys) who were small dolls on whose naked china bodies Edward used to model splendid garments of coloured wax. Sheila and I had a house in the

*A Nissen-type hut built in the 1880's by our grandfather for the Rye Volunteers.

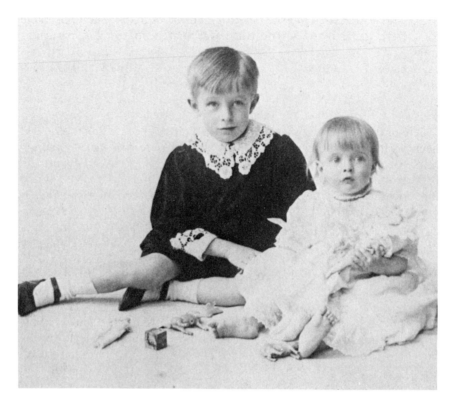

Edward with his sister Anne

cedar tree for ourselves and our dolls. We loved that house with its beautiful woods, gardens and ponds. Grandma spoilt us and we avoided Grandpa – a mutual avoidance, I fancy.

During the First World War Edward and I were taken to stay at Camber for a change of air (and probably to give Nana a rest, for she always stayed at home when we went off with Miss Forbes). I remember the enormous window of a bedroom I shared with Miss Forbes, and Edward pointing through it to some innocuous clouds, telling me they were German airships – and likely to drop bombs at any minute. It did happen once – but disappointingly for Ed, when we were not there. About such things as bombs, slums and disasters generally, he was a strange mixture of romanticism and down-to-earth realism.

As a very small boy he showed a marked dislike of parties. One of Ma's friends who had several children told Ma that she must make him be more

social, but Ma replied that she had no intention of making him miserable for purely social reasons. The truth was that he hated that particular friend's parties and always behaved badly at them because they had gas-fires, and Aunt Denny had once told him that gas-fires were dangerous and might blow up. Ed was not, in fact, unsociable. A great many friends and relations visited Springfield all the time, and he liked them all very much.

One of the most important people in Edward's life was Nana, who had been my mother's nurse, became Edward's and mine, and then went on to nurse our sister Betsy who was born in 1916. We were utterly devoted to Betsy from the moment we first saw her. She was much more like Edward than I was, and soon began to show a talent for drawing. Nana loved her as much as we did. There was nothing Nana did not know about the family, and she had a great gift for story-telling, holding us spellbound with descriptions of disasters such as the Tay Bridge horror and the sinking of the *Titanic*. Her brother was a carpenter who had helped to build the *Titanic*, so we had a deep personal interest in that story. Nana also inspired us with an admiration for Burns, Scott, Stevenson (she was Scottish) and Dickens, and she and I were fond of *Little Women* – not one of Ed's favourites. Harrison Ainsworth's *The Tower of London* was more his line, and a French book about Henry of Navarre which had an illustration showing Rastignac being dragged apart by four horses, which he would try to force me to look at. All our small squabbles were resolved by Nana. She soothed and cosseted us all (Granny, Ma and Edward particularly) through our various illnesses; and for many years Edward continued to go up to her room of an evening, when he was at home, and they would haver away together while she gently massaged his hands, legs, feet, or wherever he felt stiffest.

I do not know exactly when my parents first realized that Edward was arthritic, but I know he showed signs of it very early, and remember how as a child he was not very good at active sports and did not find it easy to run. Ma and Dah must have been worried because they took him to see a Doctor Still, who specialized in the diagnosis of arthritis in young people, and later they sent him to Bath for treatment. Edward liked Bath, but I do not think that the treatment did him any good.

During the First World War Edward was at a prep school, and the following letter was written while he was there at Northaw Place, Potters Bar, in Hertfordshire.

Dear Pa,
The Zepp raid on the North of London was most exciting. We got up in our pyjamas about 10 o'clock on Sunday evening and stayed from then onwards to about 3 o'clock on Monday morning with intervals in the

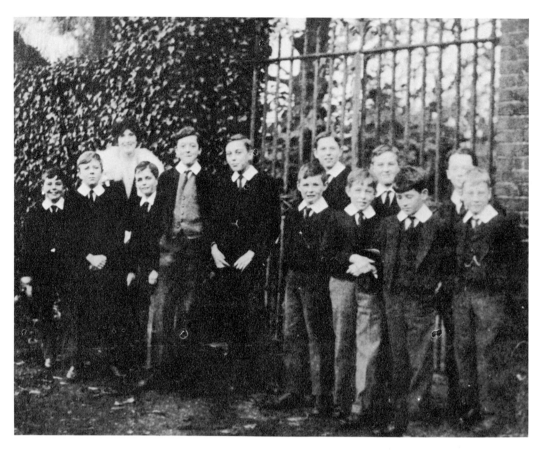

Edward is the fifth boy from the left

cellar. The cellar here is most appallingly dirty and damp. This morning we went out and collected bits of aluminium and canvas and burnt silk, the burnt silk smells horrid. I hope you will all be able to read this quite well, it is not extraordinarily good writing as I am in a hurry to get in as much as I possibly can. I am sending you and Ma some bits which I found in the garden path. I hope you will enjoy them very much indeed. Miss Lloyd the mistress who used to teach me arithmetic saw it come down in flames I wish I could go and see it, but we can't as there is so many guards and people trying to look at it. Granny Ma and Anne are coming down on Saturday. I'm afraid I must end now. Yours ever, Edward.

His taste for the dramatic developed early, as this letter shows. It is possible that those 'intervals' in the damp cellar contributed towards the illness which ended his schooldays. He was always catching cold when at school and spent a great deal of time in the sick-bay, and before he could take the

Common Entrance examination for Eton – his letters show that he was worrying about it because he was backward at mathematics – he went down with pneumonia. He was so ill that he had to be brought home, and he never went back to school.

Instead he was given lessons by the local curate, attended an art class in Rye run by a friend called Miss Bradley, and when in London had lessons with an elderly French lady who read the French newspapers with him. In 1921 he joined the School of Art at the Chelsea Polytechnic. This proved a very beneficial experience. It was there he discovered his independence as a person; and also met people of his own age, with tastes similar to his, and so made friendships which lasted throughout his life. He became increasingly engrossed in his painting, but his health often forced him to take periods of rest. He suffered from an abnormality of the blood which affected the spleen and made him very anaemic. When the anaemia attacks came he was totally exhausted. My mother suffered from this same blood condition, so she could sympathize with him. In the early winter of 1925 she took him to Bordighera, obviously hoping that a milder climate would ease his arthritis; but unfortunately he developed rheumatic fever while he was there, and was once again extremely ill.

In 1927 the family received a perfectly dreadful blow when Betsy, who was only twelve, died of meningitis. She had always seemed so well and happy that it was impossible to believe. She had been showing signs of following Edward and would cover pages of a drawing-book with her 'people'. Sometimes he used to embellish her drawings, which amused them both very much. He felt her death deeply. It is strange to remember that the doctors who were consulted in his youth always thought that *he* would be the one to die young. He lived into his seventy-first year. I think he was kept alive by his passionate interest in his work. The enormous concentration it entailed and the hours he spent daily completely absorbed did more for his health than any medicine.

Those towns described by Edward's sister, assiduously built and as assiduously destroyed, formed part of a complicated social world which engrossed Edward at the age of seven and which bore a prophetic imprint of his future tastes and humours.

In a box filled mostly with tiny china dolls, small wooden people and lead figures, it was interesting to find the last remaining buildings – one of the 'terrible tenements' and one of the 'glamorous theatres' described by Edward's sister Anne. The tenement is a rectangular bit of driftwood picked up on the beach at Camber, covered by Edward with carefully drawn and relentlessly monotonous windows like a building in the old Gorbals district of Glasgow. Its sides and top are framed by signs in bold lettering. GIN, *they state, not once but three times; and they also,*

though less insistently, proclaim STOUT, ALE *and, mysteriously,* LEMONS.

The other building is a cube, once part of a box of pictorial wooden blocks. There is no speck of a picture left but the plain wood block has been neatly metamorphosed by drawings in black and red ink into the PHOENIX THEATRE *and* BAR. *Over the entrance, above the theatre's name, are two posters on stamp paper. One offers (at 2.30),* JAY GLEIZEN *and* KRISTA LUBIN *in* WHAT FOOLS MEN. *The second says tersely* G. DILLY AS WIDOW TWANKEY. *I have a strong suspicion that the first may have existed – or if it did not, it exactly represents the kind of social drama featuring Clara Kimball Young or Pauline Fredericks which Edward was probably seeing in the cinema at this time in his childhood. G. Dilly was one of the Dilly sisters, Gladys and Phyllis, a rather louche pair who ruled the towns and were also their social leaders. Her choice of role seems a trifle bizarre.*

There exists also a minute and perfect replica of a tramcar which Edward has embellished with destinations. It will take you to DOG ISLAND *by way of* CONCORDIA SQUARE *and* KREMLIN; *or to* BINDI *via* FAN TAN STREET *and* LUNA STREET. *These evocative names are surely harbingers of the streets and markets crowded with bustling figures which he painted again and again in the early thirties. The childish games adumbrate the images of the future.* WHAT FOOLS MEN *led to the game of performing silent film sub-titles in the Velodrome Buffalo (see next chapter).*

W. E. C.

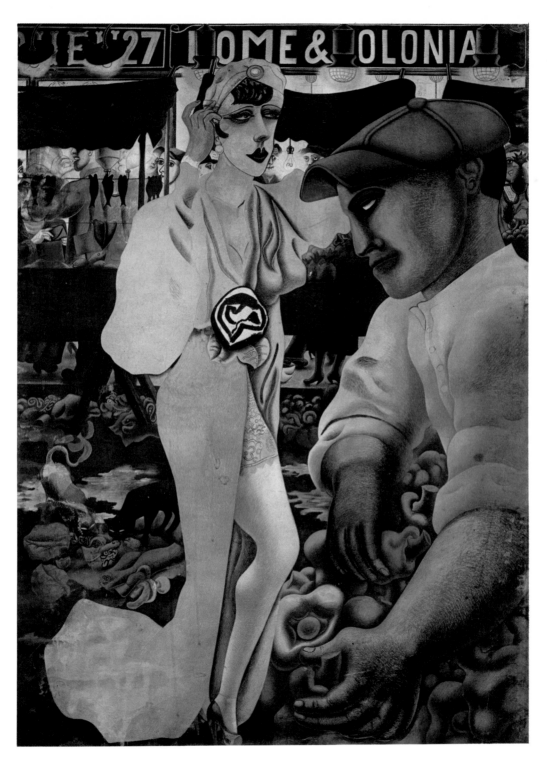

SATURDAY MARKET (1932)

Life at Springfield

WILLIAM CHAPPELL

AT A TIME when we were teenagers, I began to visit Edward at his home in the country. Unsurprisingly we did not linger with the grown-ups after dinner. Looking faintly conspiratorial we slipped out of the drawing-room, out of the house, into the honeyed air of the summer evening; made our way across a wide sloping lawn and opened a door in one of the aged brick walls dividing the garden into its separate departments. This particular door led to a flight of stone steps climbing the layered hillside of the kitchen garden.

Bathed in an effulgent golden light – breathed out equally by the warm and drowsy earth, as by the setting sun – we picked our way carefully upwards; passing, on our left, rows of well nurtured vegetables; also the wire cages protecting the raspberries, the loganberries, the currants and the strawberries. Somewhere in the vicinity of the asparagus bed, a cloud of scent assailed our nostrils from a tangled barricade of sweet peas, grown for cutting.

Reaching the summit, we sat down side by side on the topmost of the crumbling steps; there to discuss, in murmuring voices, the day's happenings; and gossip (with a deal of malicious giggling) about our friends. Eventually to fall silent and watch the rosy sky burn itself out to an ashy mauve, streaked near the horizon with bands of luminous green, spiked by a star or two.

The dusk flooded the fields, bringing silence, consisting, in truth, of innumerable tiny creaks, rustles, scratchings and chirrupings which, when sifted through the soft air, combined to produce an utter stillness.

Down below, on our right, spread the roof of the house and ahead the calm landscape of Sussex flowed away into Kent.

The house was Springfield, where Edward grew up, and lived until his forty-eighth year. It is still there; and because it represented so sweet a part of my youth I could never face seeing it again. I have not set eyes on it since the family left on July 28, 1953. I remember it clearly.

It is hidden from the road. The drive is still a curved canyon, closed in by the polished green-black walls of hedges some twenty feet, or more, high. One hedge is laurel. The other is rhododendron covered in season by

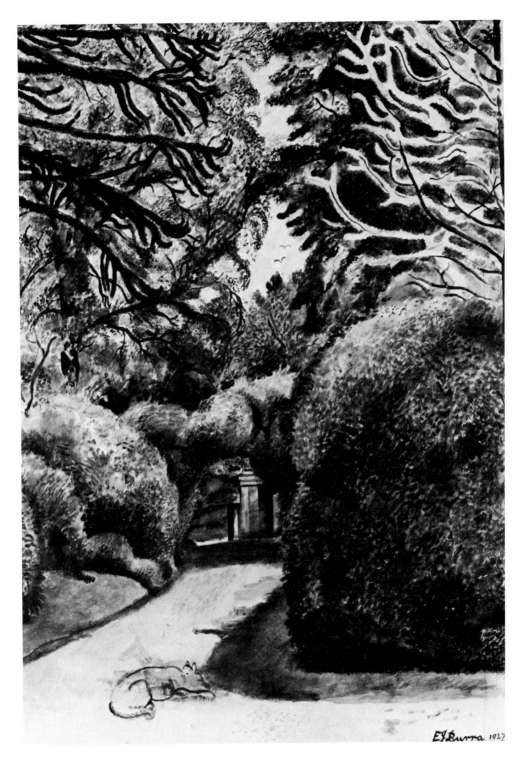

The drive at Springfield, an early watercolour

over-exuberant flower heads of a deep magentaish pink. The scale of these hedges could lead you to believe there must be a particularly imposing building at their apex. A sprawling sixteenth century manor; a Victorian Gothic pile; or a rosy bricked Georgian mansion with rows of symmetrical windows.

It is, in fact, an early Victorian* stucco box of a comfortable size with a pillared porch and large windows. The deep-eaved slate roof carries a row of dormers. It is solid, pleasing; just sufficiently capacious. Typical of many a country house belonging to an ordinary well-to-do country family.

When I knew it, as a child of fourteen, there was nothing pretentious or elaborate about it. Yet to me, fresh from my semi-detached home in a shabby southwestern suburb of London, Springfield appeared the exact house to which the heroes and heroines of E. Nesbitt and Mrs Hodgson Burnett – those Bastables and Railway Children, the Sara Crewes and the little Lord Fauntleroys – were magically transported – by various rich elderly gents – from the humiliations of a loathsome (though, naturally, genteel) poverty to a life of ease and fun in comfortable homes with sweeping gardens, delicious food and a devoted staff. Finding these assets much in evidence at Springfield was a matter for only mild surprise; as in spite of being aware that Edward stayed, during the art school term, with his grandmother who had a house in Elvaston Place (31 Ellaline Terriss, he would sometimes write at the top of his letters) I had not considered his background a subject for conjecture, other than taking it for granted – without minding at all – that most of my friends' backgrounds must be better than my own for the simple reason no other family I had so far encountered showed any signs of being as poor as mine. I was delighted with the air of comfort and wellbeing I found at Springfield, due, I suppose to the ministrations of a cook, two housemaids, a parlourmaid, two gardeners, a keeper (or handyman) and, in the eyes and bosom of the family, obviously the most important of all, a genuine old fashioned Nanny.

She was a small formidable person with sparse grey hair, a long nose, and a fairly heavy grey moustache. Edward sometimes referred to her (never to her face) as Mrs Marsupial – the governess in Aubrey Beardsley's novel Under the Hill. I was rather nervous of Nana. She marched into my bedroom on the second morning of my first visit to find me lying – never having been a great one for getting up when called – contemplating the brass hot water jug (placed on the washstand some twenty minutes earlier) covered by a towel to keep it warm. Nana glanced pointedly at the hot water jug;

*1837–1840.

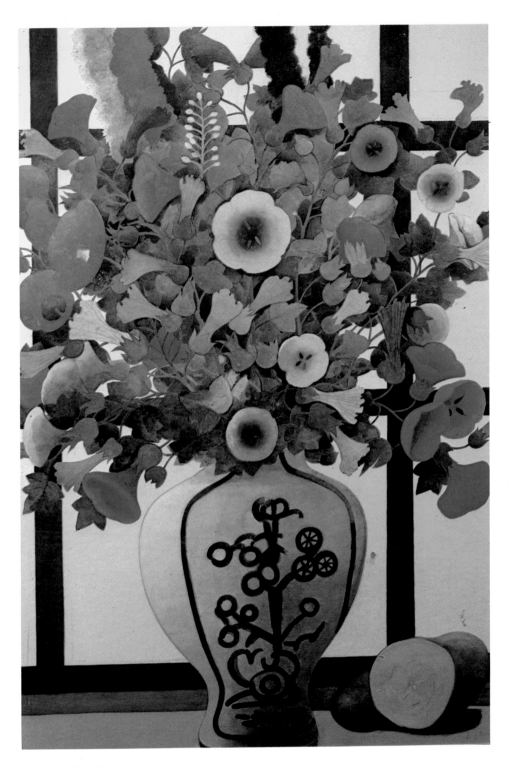

MALLOWS (1956)

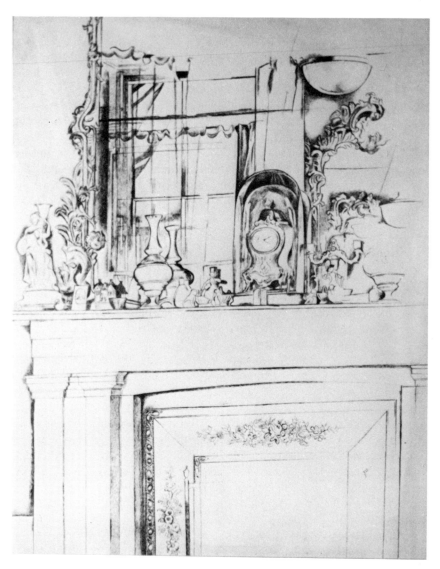

The drawing room fireplace at Springfield

then very directly at me. She folded her hands across her waist and announced in a tone both authoritative and Scottish, 'It's taime ye werrr-rup Maister Billy'. I obeyed at once. Nana was *the* voice of discipline

in the family and a wonderfully comfortable symbol of security and continuity.

Sighting, at last, the breakfast table I discovered Edward had already gone to his work room on the ground floor; a lofty apartment formerly dedicated to billiards. His absolute need to draw and paint daily was already an established fact. Another established fact – less easily understood – had to do with his rather individual disposal of furniture and objects in the unique lay-out of his working space. The pattern he set in the billiard room was to be repeated throughout his life in every place he used as a studio. The first requisite was that there should be positively no place to sit down. There were, indeed, seats; chairs and stools, and a box ottoman with a padded lid, but each and all of these were completely covered by tottering mountains built from old magazines, gramophone records, crumpled handkerchiefs, newspapers, articles of clothing, cardboard boxes, and tin lids half filled by ends of tubes and pans of paint. (I daresay it was all a devious way of making it clear to visitors they were not expected to hang about.) It was pointless to consider removing any of this accumulation of matter to the floor, as that was already smothered in deep and dusty layers of letters, postcards, cuttings, photographs, wrapping papers, and more gramophone records. Occasional foodstuffs, such as tins of sardines or corned beef (as though against siege?) helped a selection of books and some odd shoes to add shape and contour to the sociological, autobiographical, geological strata, surrounding – even engulfing – the legs of the chair where Edward sat, his bony little behind supported by an unyielding mass of old *Photoplay* mags and yellowing newspapers. This heap could be adjusted in height to suit the work in progress – lower for an oil painting, propped on his knees, the canvas leaning against the table edge (he never, to my knowledge, used an easel), higher if he were working in water colour with the paper laid flat on the table top. From the mantelshelf a very beautiful white barn owl in a glass case (years later to be used as the subject of a very beautiful painting) surveyed the scene with the fixed gaze of an idol.

Set aslant, with its lid open, a portable wind-up gramophone lay on the moon landscape of the floor. Nothing in this room was ever touched by any other hand than Edward's. This was an unwritten but unbreakable law of the house.

Settled on the extreme edge of the ottoman without disturbing the junk, I was perfectly comfortable; having inherited a family habit of never sitting back in a chair. Periodically, during the morning, Ed would swivel round on the shiny cover (Clara Bow, possibly) of *Photoplay*, and bending down would crank up the gramophone; then pick this or that jewel from his splendid collection of 78 rpms. There was a rich choice. Bessie Smith, Ethel

On holiday at Toulon

Waters, The Mound City Blue Blowers, Harry Richman, Red Nichols and his Five Pennies, Mildred Bailey, Bix Biederbecke, early Louis Armstrong, and many more. We played 'Muddy Water', 'Empty Bed Blues', 'Twelth Street Rag', 'Stormy Weather' and 'Old Rockin' Chair's got me – gin by my side'. Miss Bailey wailed sweetly and tinnily through the scratches streaking those so ill-treated and now so valuable pieces of bakelite. We did not

talk much as he worked; just sat in a comfortable silence. Sometimes Edward would glance down and digging in the heap under the table extract, and pass – held in a fastidious thumb and forefinger – some interesting item. A new handtinted postcard of a French or Italian film star; a copy of *Der Querschnitt* containing the latest drawings by George Grosz – or a letter from Barbara Ker-Seymer or Clover Pritchard almost certain to hold fairly libellous statements about nearly everyone we knew.

Towards noon, should the day be sunny, and in retrospect those summer days seemed – or so false memory assures me – always radiant, Ed might lay down his brush and we would set out for the glittering air, and the sky-reflecting dykes of the nearby marshes. Here, we could clamber among the ruins of Camber Castle, or meander nowhere and sit on a stile watching the birds and the roly-poly sheep going about their eternal feeding under the high skies.

If it were dull and wet there was always the Velodrome Buffalo, Ed's name for his grandfather's corrugated iron drill shed. It lurked behind paths lined with dusty musty laurels and was a great place for games in dreary weather. The high arched shape added dramatic echoes to any sound made beneath it, and resonantly enhanced a favourite pastime, the declaiming of real (and invented) subtitles from the silent movies. All key words were uttered as though written in capital letters. 'And so,' Ed would utter in low thrilling tones, 'FATE, the CRUEL RINGMASTER of LIFE's CIRCUS cracked his WHIP once more!' I responded irrelevantly (which was unimportant) with 'When SPRING returned to the valleys, THERE, in a small village at the foot of the ALPS, they found PEACE at last, and TRUE HAPPINESS TOGETHER'. We then collapsed into howls of delighted laughter.

Whether, on our rambling walks in the marshes, or under the echoing arch of the Velodrome Buffalo, or wandering in the gardens, we spent a great part of our time roaring with laughter. Edward's fundamental zest for living responded vividly when he was amused. In repose, the delicate modelling of his features, the broad dome of his forehead, held an air of grave melancholy. When he laughed the transformation was total. The shapes of gravity broke up; the eyes sparkled and an expression of impish wicked enjoyment altered every line of his face.

Laughter even appeared to strengthen his frail physique, already debilitated with arthritis and anaemia. The truth is, he was the fortunate possessor of an iron willpower, persisting throughout his life, and capable of producing a manufactured energy so closely resembling the real thing, it was able to support him through the demands of long walks, late nights, and hours of work. Even (when in the mood, and usually out of the blue) to performing a brilliant spoof rendering of a Spanish zapateado with

On holiday at Camber Sands, near Rye

stamping feet and wildly waving arms. This was most effective in the Velodrome B, producing a thunderous response from the sounding board of the roof.

On those mornings when it was obvious Edward was so absorbed in his painting he might well work through to lunchtime, I would sometimes go out with Betsy. She was the youngest of the children and still under the benevolent supervision of Nana. Anne, who came between Edward and Betsy, I grew to know later. At this time she was, I think, still at school so I only encountered her during holidays. Betsy was a small thin person with a lively and charming expression. She much resembled her mother in features, and she possessed, for one so young, a surprisingly sharp sense of humour akin to Edward's. We would go whirling up and down the road to Peasmarsh on bicycles. Being a novice, I continually fell off with a crash. Betsy thought this much funnier than I did. Between my tumbles I was regaled with a running commentary on the ghastliness and stupidity of the children living in the various houses we passed. They were described with a great sense of fun and ruthless gusto. She had not a good word for one of them.

Betsy was already revealing a gift for drawing, and it is tantalizing (also depressing) to wonder if another talent as strong as Edward's was lost when she died from meningitis at the age of twelve. She was the hearts' love of the whole family, and Ed with his inborn liking for children was devoted to her. He sent me a touching letter telling how he had sat by her bed after she died. 'She looked very beautiful,' he wrote, 'white as marble.'

That unthinkable sorrow was ahead. Now, the summer days sailed tranquilly by, smooth as silk. The house gave out a strongly personal atmosphere of content and serenity; a kind of agelessness in its way of life, making it seem an older building with a longer past then it could possibly have had.

Returning to lunch one day from an excursion with Betsy, I found Edward at the sideboard in the dining-room looking pale and exhausted (yet stimulated) by his morning's concentrated work. At this stage in our friendship he was always surprising me (I would have died rather than admit it) and on this particular day he ignored a glorious steak and kidney pudding, and proceeded to collect a plate of vegetables which he then doused liberally with vinegar. 'Very *sour*, dear,' he remarked with relish. 'Suits me.'

I found this amazingly perverse. I was also made to feel rather coarse and greedy as I helped myself to a large portion of the pudding. Edward had a small appetite, but he was no true vegetarian. I think he was like the Duchess's baby in *Alice*. He only did it to annoy. His parents, on the whole, ignored his eccentricities. 'Ma' and 'Dah' (as Mr and Mrs Burra were known in the family) were possibly the kindest, most tolerant, least de-manding of parents in existence. She, tiny and immaculate, appearing always as though just unwrapped from layers of white tissue paper, so freshly laundered, pressed and polished. He, tall and a little stooping; with melancholy bloodhound eyes. Returning, as usual, from our favourite vantage point at the summit of the kitchen garden – just as the night was starting to take possession of the countryside, the bats diving and twittering through the dusky air – we could see across the big verandah into the lamplit drawing-room. There they sat, Ma and Dah, in facing armchairs. She knitting. Alert, erect, her neat ankles neatly crossed. He, half dozing over his book (more than possibly a Smollett or a Trollope), his legs, long and thin as Edward's, stretched half across the hearth rug.

'*Hen*-ry,' Ed murmured in my ear in a quietly peremptory tone exactly like his mother's. 'You're *snoring*.'

It was they, Ma and Dah, who had made Edward so surprising to me. Physically, Ed resembled each of them; and his character was an amalgam of theirs.

His beautiful manners; his kindness; his generosity and compassion;

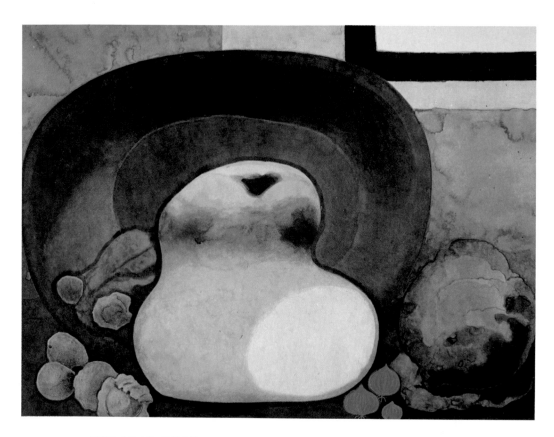

THE LOAF (1964)

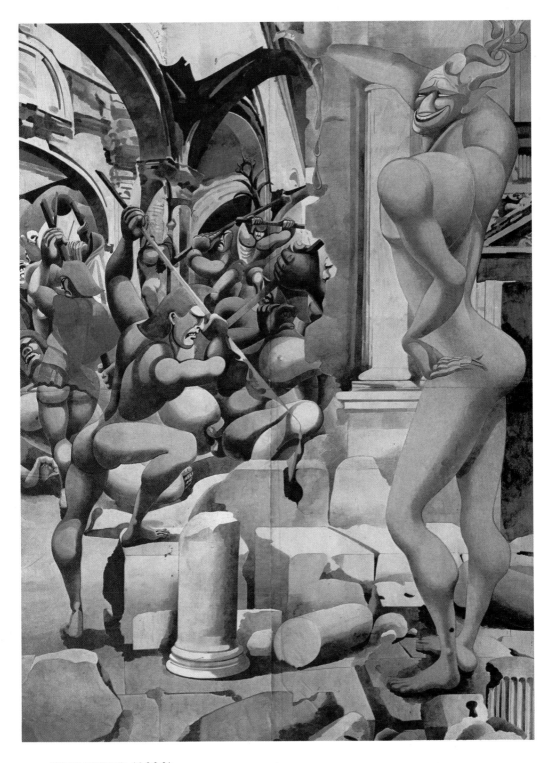

BEELZEBUB (1938)

even, probably, his talent (Dah was an amateur painter of no mean ability) came from his father. His charm; his obstinacy; his great capacity for enjoyment; his sharp wits and his sense of style came from his mother. Like most children on the edge of growing up, Edward was not particularly nice to his parents. Neither was he forthcoming – he kept them consistently uninformed as to his movements, or his whereabouts, even when it involved his planning to go away for some length of time. Any diffident enquiry would be met with a flat 'Oh, for God's sake! Don't FUSS!' Nor was he, apparently, able to show his affection for them. Yet, in all the years I knew him – I suppose better than most; possibly not as well as some – the only time I saw him weep was after the death of his mother.

Edward's personality, his nature, was full of barriers and barricades. Those who were fairly intimate with him learnt never to attempt to overthrow them. Anything he felt strongly about – such as his work – he would not discuss.

I know that he deeply loved Springfield and his life there; but it was never mentioned. He did not care for Chapel House in Rye in spite of the breathtaking view of the marshes seen from the windows of his work room. I am not sure if that view was any better than the great stretch of pastoral landscape we used to see sitting together, aged fourteen and sixteen, on the steps of the kitchen garden.

When, in the last years of his life, he moved to 2 Springfield Cottages on the edge of the grounds of his old home and discovered he was suddenly responsible for his own domesticity I think he was happier. That is another story.

The Artist

JOHN ROTHENSTEIN

JOHN AIKEN

JOHN BANTING

On a motor tour with his sister, Edward wrote in a letter, after staying in a reputedly 'good' hotel in one of the Cathedral cities, 'The barman tried to cheat me over a round of drinks but unfortunately I wasn't that drunk. I rather puzzle the staff of these hotels they find me difficult to place Ha Ha. . . .'

A good sixty per cent of the critics who reviewed his exhibitions over the years also found him difficult to place, Ha Ha. How much easier for them had he been an abstract painter. He made such definite statements in his work, they called for definite answers. The bulk of those who wrote about him were guarded. Uneasy; faintly hostile. Praise is qualified, grudging; and there is a sour humourless attitude such as people adopt when they are suspicious they are about to be laughed at. Eventually (snail slowly and very late indeed) it began to dawn on the press he might possibly have to be taken seriously. After his death – and how often this happens – the tone changes considerably.

The three Johns – Rothenstein, Aiken and Banting – were each associated with Edward within varying degrees of intimacy. They were united in a deep and growing admiration of his work.

John Rothenstein had followed his career from Art School onwards, and was active (aesthetically and practically) in bringing his paintings to the attention of the Tate Gallery who now own several splendid Burras.

John Aiken, son of the poet Conrad Aiken and himself a writer, had known and enjoyed the paintings before he became a friend. The friendship enhanced his enjoyment (and his understanding) of Edward's work.

John Banting was a close friend. He lived in Rye for a time; moving to Hastings where he found a flat in one of the crumbling Victorian terraces high up in that most individual and untypical English seaside resort. They visited one another regularly. Banting was a talented painter, and perhaps the only true British surrealist. He and Edward had much in common. Books, cooking, an idiosyncratic use of words; a fondness for down to earth pubs and popular music. John Banting was a genuine original; a gentle and humorous person; and a natural punk, long, long, before that esoteric race evolved. He painted striking portraits, strong likenesses larger than life. His portrait of Nancy Cunard is a definitive rendering of the bizarre beauty of that extraordinary personality.

W.E.C

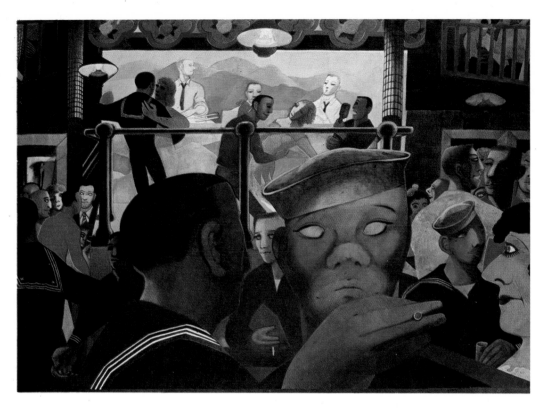

THE SILVER DOLLAR BAR (1951/52)

THE AGRICULTURAL ARMS, ISLINGTON (1974)

Edward Burra as an Artist

JOHN ROTHENSTEIN

BURRA was a unique figure – it would hardly be possible to forge a work and convincingly attribute it to his hand – who in spite of the high repute he reluctantly accepted during his later years attracted no disciples or imitators. Hs was a unique figure in several respects.

'There were many strange scholars there,' he said to me of his school, Northaw Place. At the Royal College of Art, where, aged eighteen, he went in 1923 and remained for a year, he was regarded as something of a strange scholar himself, though not in a depreciatory sense, for his knowledge of painting was exceptionally extensive. Caran d'Ache and Doré he enjoyed, but those whose influence was more enduring were El Greco, Zurbaran and Goya – his delight in Spanish painting and Spanish civilization in all its aspects was enduring – but it was from Signorelli that he learnt most; the effectiveness of hard, simple modelling and the taut pose for conveying the suggestion of restrained violence. Among contemporaries or near contemporaries he admired were, in particular, Grosz, but also figures as disparate as Beardsley, Walter Crane, Chirico, Wyndham Lewis and Dali.

His knowledge of literature was also wide-ranging, extending from Elizabethans such as Tourneur and Marston, whose *Scourge of Villainie* he particularly enjoyed, also Walpole's *Castle of Otranto*, Harrison Ainsworth's *Tower of London* and the works of Dickens (*Oliver Twist* being his favourite), down to contemporaries. These included Cendrars, Carco, Macorlan and Fuchs.

His life-studies showed him to be an exceptionally accomplished draughtsman. Anyone unacquainted with the circumstances of his boyhood might suppose that he had enjoyed exceptional advantages. In fact the contrary was the case. His health was exceptionally poor. I first came to know him when he was a student at The Royal College of Art, when he seemed to suffer from perpetual exhaustion apparently so acute as to render him incapable of action of any kind, even of standing up for long. About his condition he was candid: 'I must sit down most of the time,' he

said to me, 'If I could work lying down I'd do so.' There was, in fact, nothing about him – I had not seen his drawings – to suggest that he was already an artist of rare and abundant creativity.

But life can be a paradoxical affair and it was these seemingly catastrophic circumstances which enabled him not only to become an artist, but also to develop his rare talents from an exceptionally early age, thus sparing him the need for spending years of study of subjects irrelevant to an artist, so at the age of fourteen he was able to draw and paint without the distraction of conventional education. Finally, in his parents' view, the precariousness of his health disqualified him from other professions, and they afforded him the necessary help in following his chosen calling by enabling him to devote all his time to his art and sending him to the Chelsea Polytechnic, then to the Royal College of Art. Indeed they warmly approved of him becoming an artist, his father was an accomplished though far from prolific amateur painter himself, as were several of his relatives. The family was comfortably off, owning much property in and near Rye, so there was no concern about Ed adopting a profession with uncertain prospects. 'Strange scholar' he was, for even his earliest drawings known to me manifest both his imagination and skill, often suffused with humour. Their quality was recognized by a small group of friends he made at both colleges, among them William Chappell, Barbara Ker-Seymer, John Banting, Basil Taylor, Irene Hodgkins and Beatrice Dawson, who married Gerald Corcoran, also a close friend some years later, and director of the Lefevre Gallery, where he exhibited until the end of his life. Unlike many college friendships theirs grew closer with the years. They were drawn together by their common preoccupation not only with painting but also with the theatre (particularly ballet) and with films. When, later, he formed the habit of a fortnightly visit from Rye, his lifelong home, to London, he would stay with one or other of his friends in a spare bedroom, sometimes alluded to as 'Edward's Room'.

Burra early developed a highly personal style, so personal in fact, that even when his art had become fairly widely known it attracted, so far as I am aware, no imitators. It is a lucid style, the forms suavely modelled and almost invariably imbued by an aura of the sinister and the fantastic. One expression of his rare precocity was his adoption as his first predominant subject of the Latin South, the Spanish-speaking in particular; its underworld and the sinister aspects of its life. This he expressed in several works before he had ever visited the Continent. These were products of his imagination, stimulated and nourished by picaresque literature in several languages and also by the study of picture postcards. His first Continental visit was to Paris, where 'chaperoned' by the Henry Rushburys he and Chappell spent some time soon after leaving the Royal College. Not long

afterwards, with Chappell and several other friends, he visited Cassis, Marseilles and Toulon.

In 1930 he was included in an expedition initiated by Paul Nash, who lived at Iden and moved to Rye at the end of the year and also became a close friend. 'We took along Edward Burra a young painter who lives at Rye' which is not far from Iden, 'an eccentric talented delicate creature, extremely amusing', he wrote in a letter to a friend. They went for a few days to Paris on their way to Toulon, Nice and neighbouring places.

From his student days until the middle 1930s his principal subject was the low life of Mediterranean ports, brothels, sailors' cafés, night-clubs, occasional near-abstract versions of such subjects, an elaborate caricature of Mae West, as well as straightforward still-lifes. Many of his early works are representations of evil of various kinds, but without censure, ridicule or condonation. It was simply that in his early years evil, which he depicted with horror tinged with amusement, was the feature of humanity on which his interest – as an artist – was habitually focused. This innate characteristic was perhaps enhanced by its contrast with the uneventful, sober regularity of his own life in Rye.

An extraordinary feature of his paintings made after his expedition abroad was that even the most elaborate and detailed were made without preparatory studies or even the briefest notes.

Almost all his work – a few collages apart – is in watercolour, pen and ink, or pencil – this not from any antipathy to oil, but because he became convinced that nobody liked his oil painting, a medium which had he been more encouraged he would probably have adopted. He developed, how-ever, a watercolour technique which gave his work the character of oil painting. This he achieved by going over and over, for an hour or more, a minute part of the picture, say an inch or two, until the surface was unrecognizable as ordinary watercolour.

The countries that appealed to him most deeply were Spain and Mexico (he taught himself Spanish by the Hugo method). He was haunted by Spanish art – the three artists referred to in particular – and certain aspects of Spanish civilization, and this before he had ever visited Spain.

Burra's Hispanic preoccupations received encouragement and help from Conrad Aiken, the poet, essayist and novelist, a friend and neighbour – he and his wife rented Jeakes House in Rye – with whom he was brought in touch in 1931 by Paul Nash. In 1933 Aiken and Burra met in Spain and made a brief expedition to Spanish Morocco. On his second American visit in 1937 (on the first, in 1934, Burra travelled by himself from New York to Mexico) they visited Mexico City and Cuenavaca together. Burra also revisited New York in 1948 and 1955 and the Aikens at their home in Brewster, Cape Cod. His last association with the Aikens was quasi-

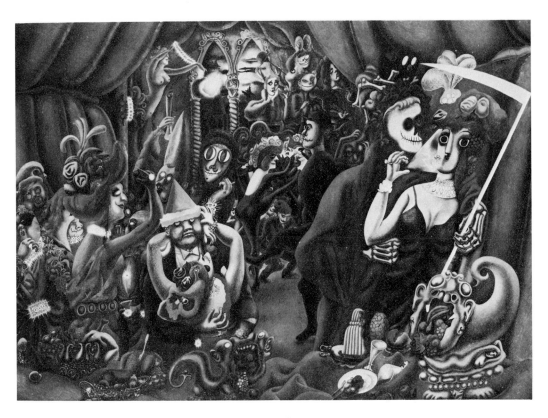

John Deth (1931/32), inspired by Conrad Aiken's poem

posthumous: he left some works in Boston for an exhibition in a gallery there. Aiken collected them but died not long afterwards and they were returned to England by his widow shortly after Burra's own death.

Burra's finest painting, 'John Deth', of 1952 was inspired by Aiken's *John Deth and Other Poems* published in 1934 and Burra figures in his autobiographical essay *Ushant*, published in 1952. In 'John Deth' the figure of death intrudes on a group of dancers (the background suggests that they may be on a stage) who are stricken by panic. The painting is a rare admixture of horror with macabre comedy. This is most dramatically exemplified by the expression of terror on the coarse, fat face of a man incongruously wearing a paper hat who, embracing a woman recumbent on the floor, sees Death kissing another woman nearby. There is a crowd of figures. Even had Burra chosen to represent Death and his victim and the ludicrously coarse-faced figure stricken by terror as subjects of separate works they would still be impressive, but the fact that they are only two features, if the most important, in a work of immense complexity, clearly exemplifies his mastery. Although it is the most impressive it is not the final

work of a character that by natural development or by circumstance was to be radically changed.

Towards the middle 1930s he had expressed – and with a rare perceptiveness – sinister-humorous aspects of the 'red-light' life of the waterside Mediterranean and other places. He was not an artist to repeat himself indefinitely, so change was inevitable. Change was also precipitated by an exterior circumstance. 'Just before the beginning of the Spanish Civil War I happened to be in Madrid,' he said to me. 'One day I was lunching with some Spanish friends. Smoke kept blowing by the restaurant window. I asked where it came from. "Oh, it's nothing," someone answered with a gesture of impatience, "it's only a church being burnt." That made me feel sick. It was terrifying: constant strikes, churches on fire, and pent-up hatred everywhere. Everyone knew that something appalling was about to happen.'

Whether his distress was due to the burning building being a church is a question difficult to answer. Many of his works do indeed represent aspects of evil, but there are many, also, of religious subjects. Among these are 'The Agony in the Garden' of 1936, 'The Vision of St Theresa', 'Holy Week, Seville', 'Mexican Church' at the Tate, 'Resting Angel' and 'Resurrection', all five of 1948 or thereabouts, 'The Coronation of The Virgin' and 'The Mocking of Christ', at the University of Dundee, both of 1952, and 'Salome, Herod and Herodias', of about 1969.

Burra was not a practising Christian but an intense religious sense is apparent in much of his work. Indeed for a man so frequently preoccupied with evil, especially one whose own character was not evil, an acute consciousness of its opposite, is readily comprehensible.

When he was a student at the Royal College of Art I was merely acquainted with Burra. It was not until the 1930s – owing to prolonged absences from London, which involved missing his two earliest exhibitions (those at the Leicester Galleries in 1929 and 1932) that I came to know and be fascinated by his work, and in 1939 brought his 'Harlem' and 'Dancing Skeletons' both of 1934, before the Trustees of the Tate Gallery, who acquired them and the following year 'Mexican Church' of about 1936 and the just completed 'Wake'.

Sir Kenneth Clark, sympathetically aware of my admiration for Burra, invited me, in 1942, to contribute a small volume on his work to *Penguin Modern Painters* of which he was editor, published in 1945. It seemed to please him, for he wrote in January 1943, '. . . I believe it will fulfil the chief duty of criticism by making people look at his work sympathetically for the first time . . .'

The book, like the rest of the series, was received in a friendly fashion, but it made, I think, little difference to the prevailing attitude in the art

world, namely that Burra was not a 'serious' artist at all, but a clever pseudo-caricaturist of the social underworld. Some thirty years later when a retrospective exhibition consisting of a hundred and forty-five of his works was held at the Tate, apart from the seven belonging to the Gallery itself, only six came from public collections. On no previous occasion, moreover, had an exhibition of his work been held in a public art gallery. He was then seventy years old. He had won, however, the admiration of a number of his fellow-artists. Paul Nash and Wyndham Lewis both told me that they regarded him as among the finest living painters; Lewis in *The Listener* (9 June 1949) wrote, 'I share Burra's emotions regarding war: when I see the purple bottoms of his military ruffians in athletic action against other stout though fiendish fellows, I recognize a brother'.

It was in the course of preparation for the Penguin book that I came to know Burra; we became friends, though never intimate, and on 15 September 1942 I paid him the first of several visits. It was an event I have never forgotten. He was living at Springfield, his parents' house in Rye. It is early Victorian, of a pleasantly conventional character with a hall where golf-culbs and fishing tackle and shotguns leaned and tweed overcoats and mackintoshes hung. The staircase wall was adorned by Victorian water-colours. When I reached Burra's studio at the top the contrast was startling: I was faced by a framed, close-up photograph of a head far gone in leprosy. Burra looked pale and ill; he wore a shabby suit and a green shirt. The studio was densely packed with a wide variety of objects. The walls were covered almost entirely by photographs of paintings, many by Spanish masters, including El Greco, Zurbaran, Goya, as well as by Signorelli, Tiepolo, Magnasco, among them pictures clipped from newspapers and periodicals, many representing dramatic incidents. Scattered over his wireless and most of the floor was a profusion of books, including Spanish and Italian novels, big scrapbooks containing photographs of Spanish and Mexican churches, mostly Jesuit, illustrated magazines and gramophone records (to which he listened while he worked, Berlioz being a favourite composer). His own works were curled up in long white paper cylinders, except for a few framed, returned from exhibitions, leaned against the walls.

His small work-table stood beside a window. 'There never seems to be light enough,' he complained, 'and I can't work by electric light.'

After we had looked at all his paintings, drawings and a few collages, he suggested that we walk around the walled gardens: romantic places. The gentle movement – we spent some hours perambulating there – seemed to stimulate him. He showed interest in the plants of which indeed he had made a number of early watercolours, as he had of the interior of the house. We spoke of the Spanish Civil War. He admitted he was pro-Franco,

'but,' he said, 'don't put that in the book.' I still doubt whether in fact he had Fascist sympathies and believed he was prejudiced against their opponents by the burning of the church he saw. I never heard him express such sympathies – being pro-Franco apart – which I believe I would have done had he nourished them. One of his many peculiarities was that he was well informed on many subjects, politics (though they did not greatly interest him) included. Yet in the chaos of his studio were littered numerous copies of the most 'popular' newspapers but only here and there a *Times*.

Among the works he had shown me was one which I particularly admired, 'a big picture of conquistadors' was how I described it. We went back to the studio and got it out. 'Oh! *that* was the one you wanted, was it? But it's of *this* war: those are *British* soldiers, just outside Rye, and I painted it last year.' It had been shown at the Redfern Gallery as 'Soldiers'; so that its subject should be clear he changed the title to 'Soldiers at Rye'. It seemed to me one of his finest works and when shortly afterwards the now defunct *Studio* offered to present a picture to the Tate, my recommendation of it, to my delight, was accepted by the Trustees.

The change of title was a routine matter, for although all his works represent specific subjects he did not give them titles until their exhibition was planned. 'Then somebody comes along, stamps them with my signature with a rubber stamp and presses me to invent titles for them.' Their subjects, however specific, are not always comprehensible to someone unfamiliar with them, and there is sometimes an element of the unconscious about his procedures. In response to my enquiry about the meaning of one work he laughed and said, 'Bring a psychiatrist and we'll find out.'

The Second World War intensified his sense of the tragedy of life which resulted from the Civil War in Spain. Discussing the terrible situation he said that it was clear that this was was the inevitable culmination of the other. Yet his obsession with its tragedy did not impair the element of sardonic humour with which he regarded it and which was apparent in a letter dated 1 October: '. . . About two days after you left a bomb or two fell round. The cinema suddenly turned into one of its news reels. I came on a very *romantic* scene. "Improved" into the loveliest ruin with a crowd of picturesquely dressed figurants poking about in the yellowish dust. Many more bombs and ye anciente towne wont have a whole window let alone a ceiling up – a very pretty little late 18th or early 19th Wesleyan Chappell went as well in the hubbub I now notice an anti aircraft gun outside the door . . .' (After the war his family moved from Springfield and their new house was built on the site of 'the loveliest ruin' Burra described, and named Chapel House.)

Earlier in the same letter is an expression of his rare, almost total, lack of ambition. '. . . The Redfern are all wide eyed over me and want to give me

an exhibition all to myself in Nov. & December Mrs Corcoran says it would be a good thing. I suppose it would but I cant bear exhibitions they make me quite ill . . .' The reviews were often left unread. When the offer of a CBE arrived he would have failed to respond had a friend who happened to be with him not written an acceptance on his behalf, and an invitation to become an Associate of the Royal Academy evoked no response at all.

Like the Spanish Civil War the Second World War inspired several moving works of art, of which 'Camouflage' of 1938 and 'Soldiers at Rye', already referred to, are perhaps the finest.

Burra did not continue to represent subjects after he had given them the fullest expression of which he was capable. The red-light life of Mediterranean cities, Harlem, New York and Boston, then the Spanish Civil War and finally the far more terrible Second World War. Eventually, he had said all that was in him to say about these subjects. The consequence was he came eventually to feel that the world had become so nightmarish a place there was no longer any significance in the subjects he had represented in a manner so sinister yet tinged with satiric humour.

Accordingly he changed the focus of his view of his environment, away from people to landscape and still-life. Discussing this change I recalled that David Low had said to me that something of the satire had gone out of his caricatures, when the world had become so horrific a place. 'What,' he had asked, 'can a satirist do with Auschwitz?' 'I entirely agree,' Burra said, 'so many appalling things happen that one's response diminishes. Still,' he added, 'everything *looks* menacing.'

Burra became less concerned with sinister subjects though he still from time to time invested the most ordinary subjects with a sinister aura, for instance 'Bottles in a Landscape' of 1953, at the British Museum, 'Owl & Quinces' of about 1953, 'The Tunnel' of 1966 or 'Valley & River, Yorkshire', painted in the 1970s. In fact it is scarcely an exaggeration to say that his conventionally realistic works are rarities – such as 'Flowers in a Pot' of about 1957, or 'Flowers' of about 1965 – works which if shown in a mixed exhibition would not cause any but a specialist in his work to say 'that's a Burra'.

Instead of frequenting the Latin world – to which however he still made occasional expeditions – he visited Scotland, Ireland and Yorkshire, with his sister, Anne Ritchie; also Devon, Cornwall, Sussex, the Lake District, East Anglia and elsewhere. Unlike the flowerpieces almost all the landscapes, even those of Rye – a place with which he was apt to express boredom – are imbued with an element of strangeness liable to make even a spectator familiar with them feel that he is seeing them for the first time. It is characteristic of the oddity of his character that in spite of his boredom with Rye, he spent all his life there apart from his travels and bi-monthly

visits to his friends in London, although he could have afforded to settle elsewhere had he wished.

There was one rare feature about his technical procedures: he never made preliminary studies of his subjects on the spot. In his representations of Mediterranean or American night-life, imagination could augment memory; where landscape was concerned, representation from memory alone was a more extraordinary achievement, a memory charged with lucidly though selectively remembered detail. There was one respect in which this lucidity became modified. 'I don't believe I *see* atmosphere,' he once said to me, yet in his later years mist and clouds feature occasionally in his work. 'There is a time-lag between my seeing a landscape,' he said to me, 'and my coming to the boil, so to say, but when I go back I'm puzzled by what I've left out.'

For Burra I have long had a profound admiration and the longer I contemplate his work the more convinced I become that he is among the outstanding artists of his generation: his power both of endowing figures with a rare degree of menace, animated at times with a touch of school-boyish humour; and 'ordinary' subjects, landscapes, railway tracks, even still-lifes – except his relatively conventional representation of flowers – with overtones almost always of an arresting strangeness. In the earlier part of his life he made use of postcards, and when it served his purpose also of the work of other artists – he could hardly have painted his 'Still Life with Basket', of about 1937 unless he had seen Dali's 'The Bread Basket' of 1926, or else a similar work by this artist whom he particularly admired – but such was his originality that his use, somewhat infrequent, of the work of others, however conspicuous, never impaired his own. His willingness to borrow, although infrequent, is entirely frank, and one manifestation of his absence of ambition: he had no more ambition to be thought 'original' than meritorious in any other way. He made a set of woodcuts which he even forgot until they were discovered by Barrie Penrose in 1931 among the rubbish of his studio long after they were made. 'Thought they'd been thrown out to the wolves years ago. Filthy old things,' was his comment.

He desired, passionately, to paint and draw, but although he was pleased by the admiration of his circle of friends he had no desire for 'recognition': had no gallery been ready to exhibit his work he would, I believe, have been indifferent.

Among his many rare qualities was the manner in which he withstood, or rather indeed ignored his serious and lifelong constitutional infirmities. He worked regularly and solidly every day he spent at home, rarely sleeping for more than five hours.

Burra's imaginative power was marked by grandly massive and auda-cious forms, even at a slight distance not discernible as water-colours, and

his drawing by an exquisite precision which made, strangely, the more impressive the element of sardonic humour. It is hardly surprising that he had no imitators: his combination of originality with complexity and power would make imitation a baffling undertaking.

A Memoir

JOHN AIKEN

IN THE SUMMER OF 1948 a one-man show was held in the Swetzoff
Gallery in Boston, Mass, of the paintings of an English artist whose strong
individualism attracted a good deal of attention. His work was then little
known in the United States, although some of it had appeared in a Surreal-
ist exhibition in the Museum of Modern Art in New York, more than ten
years earlier.

His name was Edward Burra. Many of the paintings at the Swetzoff held
a hint or more of the sinister, sometimes of the evil, lying close beneath an
ostensibly normal surface of life in cafés; or in churches. In some were
epicene angelic figures reminiscent of Blake; some were violent; in many,
the expressions of the human characters showed, with wonderful clarity,
cruelty, cynicism or greed. These elements pervaded much of his work up
to early middle age (he was then forty-three). A reporter at the show asked
him why he painted this way. 'I get a bad feeling,' he said.

This remark – very characteristic in its simplicity and directness – was, I
believe, sincere and also deeply true. Ed, as we called him (he was a family
friend of two generations of Aikens) was perpetually fascinated by the
thinness of the veneer of social and moral behaviour which overlies the
darknesses of the human spirit, themselves allied, he believed, to cosmic
evils. From boyhood he was, like me, a devotee of science-fiction, that
art-form generated in pulp magazines which has now become respectable.
One of his favourite writers in this genre was H. P. Lovecraft, the founder of
an esoteric school of horror fiction with its own geography and biblio-
graphy, centred partly round a mythical region of New England. A special-
ty of this school was its peculiarly horrible gelatinous or totally amorphous
primeval monsters. One of these – in aspect somewhere between mocking
and horrific – sits in the middle distance of his painting 'The Visitors',
otherwise a dream-like landscape with two gigantic avians in the fore-
ground which would be equally at home in the Garden of Delights. The
record sleeve he designed for my father's reading of his long poem 'Blues
for Ruby Matrix' has for its dominating figure a scarlet lady who is half-way
to being a cockatoo. Indeed, Ed's work was influenced by a number of
painters ancient and contemporary: Bosch, Dali, Goya, Ernst, El Greco,

Füseli . . . ; but these influences he quite subordinated to his own integrity of purpose. He saw very clearly what he wished to achieve; and, himself a complete craftsman, assimilated what he needed of the technical minutiae and the pictorial ideas of others.

As time went on, the element of fantasy and the macabre ('macabre' was one of Ed's favourite words) shrank (but stayed) as he turned to more realistic, and often more rural, subjects – as in 'Romney Marsh' where the serene green landscape, backed by the unseen sea, is overhung by three awesome waterspout columns. Again, his more recent large landscapes from the west of England, Yorkshire and his own Sussex, are characteristically slashed by a railway-cutting, or pounded by juggernaut trucks. He retained through his life strong feelings about the rape and pollution of the countryside; paradoxically enjoying none the less the grime and squalor of back-street city life.

From middle-age on, his hands – and feet – were badly gnarled by arthritis. He had to spread his big sheets of paper on a horizontal surface, in fact a dining-table. This and the painting itself became covered with auxiliaries – paints, brushes, ashtrays, books, drinks (Ed could only hold a tumbler by the rim, between thumb and forefinger) and little pots of rinse-water. I once clumsily knocked over one of these onto a half-completed arabesque of flowering vines, and smeared it. 'Don't worry,' he said. 'I'll make that into something.'

In the years when I knew him best, he was most concerned with time and not wasting it. This was why he didn't put things away. 'You only have to get them out again,' he said. (He always knew where they were.) He withdrew himself quickly from bores and from the over-earnest. Awarded the CBE in 1971, he didn't attend the presentation, nor, later, the accession of his brother-in-law, who became Lord Ritchie of Dundee, to the House of Lords. When the BBC, in one of its more inspired moments, planned a half-hour film on Ed and his life in Rye, he viewed the prospect with horror and couldn't understand how he'd ever come to agree to it. In the event he enjoyed it enormously. 'I was drunk for three days,' he said. It was one of the funniest films I've ever seen. In his deadpan, throwaway, beautifully articulated drawl, he made risible rings round his young interviewer. Obviously she, too, much enjoyed this. Towards the end she asks him why people go to see his pictures.

'To improve their minds, dear.'

'How can they imagine *that*?'

'*I* don't know!' he says, collapsing into his nearly silent laughter.

I'll never forget a shot from this film of Ed on Rye railway station, at a time when British Rail – as often – were planning to close the local line. This was his link with London and his friends: although he spent most of

his life in Rye, he professed to detest it and most of its inhabitants, and went about it by daylight as little as possible. In the film he is shown standing on the deserted platform, shrugging, spreading his hands, and saying 'What – no trains?' They didn't close the line.

Although never in very good health, Ed had a strong and resistant basic constitution which came, I think, from his deep continuous enjoyment of life. Around his seventieth year he had two serious accidents within a span of two years and recovered completely from both. In the second of these he broke his hip, which had to be pinned. During his convalescence, what he suffered most was the enforced abstention from painting. He showed great fortitude and contempt for pain in getting himself mobile and alone once more: he needed lots of solitude. Mercifully, his final illness was very brief.

Ed's painting method, developed quickly and early by trial and not much error, was well suited to his needs: dense, solid water-colour, laid on with a draughtsman's brush, often to a Dali-like sharpness of line, modelling and perspective. He was a wonderful draughtsman, as a result of a rigorously self-imposed apprenticeship; and had a mild but dismissive contempt for those contemporary artists (amongst whom, good friend though he was, he numbered Paul Nash) who could not draw. He never, or almost never, painted from life, or from the landscape, but he sometimes used postcards as aides-memoire. He didn't really need them, though: his memory for the fine and critical detail was extraordinary, and gave to the scene a sublimation of its quintessence.

His physical needs were simple. Perhaps this was why, as he once told my wife, he didn't sell a picture until he was forty: he painted as he pleased. He liked good-value meals in side-street pubs with atmosphere, liver-sausage sandwiches or fish and chips in cafés with a raffish clientele. We used to take him to lunch in the Queen's Head in Rye (he didn't mind Rye by day so long as he was with friends): an unpretentious pub with a dining room which spilled over into the bar. 'It's a peachy place,' he once said. But he was a connoisseur – and an excellent cook – of vegetables, and mostly preferred his own cooking to that of his friends. He was shy about ordering things in bars and restaurants, but from time to time would slip a large banknote into one's hand, saying for example, 'That'll pay for a few brussels sprouts.'

Ed's sense of humour infused a lot of his painting and, like the rest of him, was highly personal.

One of the pleasantest things in the last year of our friendship arose from the visit my wife and I made in September 1976 to my stepmother, Mary Aiken, on Cape Cod. (Ed would have come too if he'd been well, and mobile, enough.) In the attic of Mary's house in Brewster were eleven of Ed's paintings, left over from the years-ago Boston show and rescued by

Mary because they had no certain destination. These were a splendid selection from a variety of Ed's middle-period subjects: apocalyptic, comic-horrific, sleazy, grim. Mary had long been worried about the responsibility and transport risks they represented (they were mounted and enormously heavy). As a first insurance against their removal, we photographed them. They are now, except for a remarkable 'Gethsemane' which Ed presented to Mary, in the Lefevre Gallery in London. In the week before Ed's last illness, my wife took him a set of prints (and while in his cottage, photographed him for the last time). She left him gleefully examining the photographs: he had completely forgotten the paintings' existence. 'I'm quite overcome,' he said. 'I'm going to *study* these.' It was the last time either of us saw him.

His last completed painting was of a local hill, one of his – and my – favourite pieces of Sussex countryside. Called Stone Cliff, it lies between Appledore and Rye, overlooking the Royal Military Canal: it is the seaward prow of the Isle of Oxney, still so called although the sea has now retreated miles to the southward. Though no more than two hundred feet high, it forms an impressive ridge, since on the west side it rises steeply almost from sea-level and looks more like one of the great whaleback ridges of the Yorkshire Dales than the usual south-country hill. Normally a rich green, dappled with grazing sheep and pleated and furrowed with a micro-infinity of workings and animal tracks, it was in the great British drought of 1976 burnt to a wonderful range of shades of gold and warm brown. I like to think that my pointing this out to Ed as we drove past it, not many months before his death, inspired him to paint it – as always, from memory.

He was a complete painter, but inimitable: his work will found no school. Nevertheless, he was to me one of the greatest and most original British painters of any century. Throughout his life he had trained himself to a level of craftsmanship ideally matched with his unique creative imagination. At all times he knew exactly the effect he wanted and had the technical means to achieve it. The essential calm of his later work thus corresponded to a growing spiritual calm, and in his last years he had become, I think, one of the happiest men I have known.

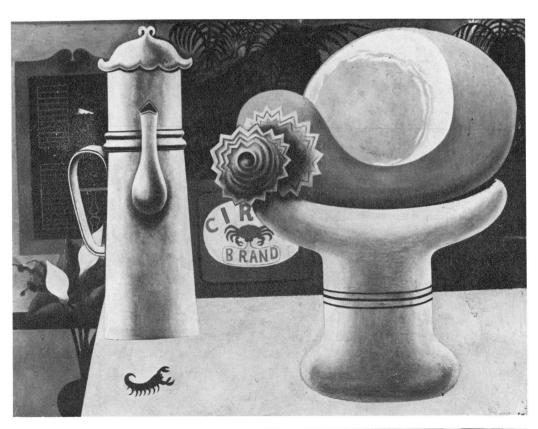

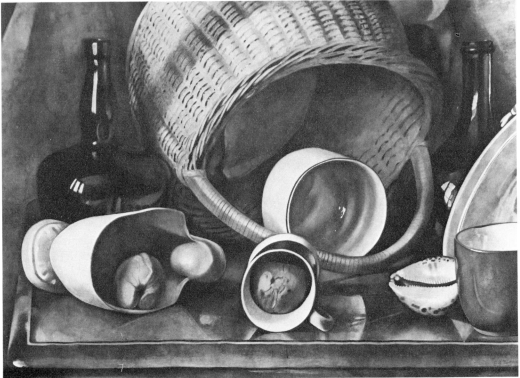

The Painter

JOHN BANTING

I HAZARD A GUESS that the mystery of Burra's paintings begins with an object which turns into a face with a thought behind it. Or is it the other way round? In any case a patient improvisation goes on – Wonder? Mystery? I am no 'lay analyst'.

They do not present one aspect but unfold like a book so that each day one reads another fresh chapter or finds an unnoticed detail. Some copy-book theoreticians would dub this as 'literary painting' ... as though saying 'A painter may be seen but not state', like a child during past more oppressive times. Yet the Old Masters were 'literary' in their various degrees. They were not delightful decorators only making domesticity more burdensome and ostentatious. All is allowed to Hieronymus Bosch, partly owing to his impressive antiquity and dazzling skill. But his wandering symbolism does not involve Burra who satirizes the present with an alarming gentleness, sympathy and an abandoned feeling of nonsense. His world is not pestered by vain attempts to rationalize. It is the topsy-turvy world we somehow live in very clearly realized by him with relentless *trompe l'oeil* exploding into a grotesque distortion such as a wild event of a William Burroughs type – horrific and comic.

His works vary, for he is no authoritarian copying himself, but they are strung together in an uninhibited way by their umbilical cords. They relate.

One can see that praise or blame affects him but little and that he paints for the high zest of it rather than to Live Securely. He is free from dogmas and frontiers of thought, for all have been duly digested and evacuated. His skill is by no means an end in itself and does not restrict him into a display of craftsmanship. It enlightens the eye and gives many thoughts and sensations. I see no good reason why a painter should not do this – if *he is able*. 'Painterly painting' is inadequate. One needs more than something fine to look at – more than suffocating furniture on the walls. One needs a journey with adventures even if they do not always have a happy ending.

Opposite top *One of Burra's rare oils, painted in 1931*
Bottom *Unbelievably, this still-life is a watercolour*

Evolution is moving quicker now and in an alarming way, yet the human species is becoming immune and even capable of complete transformation. Dr Albert Szent-Gyorgi (Nobel biologist) gives it only a few more decades. Burra points a warning finger, and a protective respite from overwhelming fear. He is not unaware, neither is he an escapist. He has assimilated (and seems to give out) music of all kinds – pop, Tchaikovsky, hard rock, Bach, trad, early blues, even nauseous 'palm court' and hackneyed 'semi-classical'. He thinks, feels, listens and is no conveyor-belt painter. He laughs a lot in many of his works – variegated types of laughter, and the ability to laugh is a valuable talent.

The Designer

FREDERICK ASHTON

NINETTE DE VALOIS

Between the early 1930s and the late 1950s Edward Burra designed eight impor-
tant works for the theatre: Six ballets, one opera, and a musical play.
In chronological order the productions were:

(1) Rio Grande *Ballet by Frederick Ashton to an orchestral and choral work by*
Constant Lambert; words by Sacheverell Sitwell; and costumes and decor by
Edward Burra. The ballet was commissioned by Maynard Keynes for the
Camargo Society, and the first performance was given at the Savoy Theatre on
November the 29th, 1932. Ashton choreographed one of his most dazzling
solos danced by Walter Gore to a brilliantly rhythmic piano interlude. The
production joined the repertoire of the Vic Wells Ballet in 1935, and opened at
Sadlers Wells Theatre on March 26th; with an offending nude on the back
cloth (part of a fountain, based on one in Toulon) covered, by order of Lillian
Baylis, with a carefully painted stream of water!

(2) Barabau *Ballet by Ninette De Valois (in which she made a ravishing*
appearance); music by Vittorio Rieti with a decor and costumes by Burra; first
performance at Sadlers Wells Theatre on the 17th April 1936. This ballet was
originally performed (in another version) by the Diaghilev Ballet with a setting
and costumes by Maurice Utrillo.

(3) Miracle in the Gorbals *Ballet by Robert Helpmann on a story by Michael*
Benthall, with a good strong melodramatic plot, reminiscent of a hammy old
play, The Passing of the Third Floor Back *and with undertones of Somerset*
Maugham's Sadie Thompson. The score was by Arthur Bliss and Burra's
decor of the Gorbals and the docks district of Glasgow was sombre and very
powerful. The first performance was given at the Princes Theatre (now the
Shaftesbury) on the 26th of October 1944.

(4) Carmen *Opera by Bizet. Directed by Henry Cass with decor and costumes by*
Burra, opened at the Royal Opera House, Covent Garden on January 14th
1947.

(5) Don Juan *Ballet by Frederick Ashton to the music of Richard Strauss.*
Designed by Burra. First performance at the Royal Opera House, Covent
Garden on November 25th 1948.

(6) Don Quixote *Ballet by Ninette De Valois to music by Roberto Gerhard.*
Magnificent evocation of Cervantes' Spain by Burra. First performance at the
Royal Opera House, Covent Garden, on 20th February 1950.

(7) Simply Heavenly *A musical comedy with book and lyrics by the black poet*
Langston Hughes. The music by David Martin. It was set in Harlem (a locale
dear to Edward's heart) and had a high style black cast including Bertice

Reading and Earl Cameron. Burra provided a perfect composite set; and the piece was directed by the actor and movie star Lawrence Harvey. It opened at the Adelphi Theatre on May 20th 1958.

(8) Canterbury Prologue *Ballet after Chaucer by David Paltenghi (a close friend of Burra's) made for the Ballet Rambert in 1951. Burra's drawings for the costume designs were wonderfully humorous and showed his usual strong sense of character. He did a simple, but striking setting.*

Edward Burra's graphic work included an A.B.C. of the Theatre *published in the 1930s by the Cresset Press. The verses by Humbert Wolfe were of little interest. The astringent satirical pen and ink drawings of theatrical celebrities of the period by Burra are well worth a close study. The detail is fascinating.*

 He also did a great many dramatic black and white (pen and brush) illustrations for an edition of Mark Twain's Huckleberry Finn *published in 1948 by Paul Elek. Later, he was one of the many famous painters and engravers who contributed drawings to the Oxford Illustrated Bible.*

<div align="right">W.E.C.</div>

Back cloth for Rio Grande. *The nude figure was finally almost obliterated by order of Lilian Bayliss*

'Such brilliant things. . .'

FREDERICK ASHTON

WHEN THE CAMARGO SOCIETY asked me to do a new ballet in the early nineteen thirties I chose Constant Lambert's *Rio Grande*. It was sub-titled 'A Day in a Southern Port', which might well have been the title for one of Edward Burra's own paintings. I asked that he should design the piece and was pleased when he accepted. His sets and costumes were immensely successful – also nicely controversial – so it seems quite absurd that seventeen years were to pass before he designed another ballet for me. I did, in fact, work with him once during the thirties (but this time as a dancer) in De Valois's production of *Barabau* which, like *Rio Grande*, was a choral work;a form of ballet score very popular in those days. I suppose if it had not been for the dreadful interruption of the war, sending all of us off in every direction, we would have done another ballet together soon after *Rio Grande*; but Rye, where Edward lived, became a prohibited zone early in the war as it was bang in the path of the always expected invasion. Edward remained at home; firmly painting throughout all the invasion scares.

He was wonderfully good company, very funny and full of oblique humour. He inspired affection and responded to it, and was incredibly easy to work with. Looking back I can see how much he extended the horizons of my imagination. The sharpness and clarity with which he observed the human scene made his work in the theatre both potent and truthful.

I found it unusual to work with a designer who never appeared to resent any criticism. If I showed the least hesitation in approving a design he would immediately produce a flood of alternative ideas, beautiful, or surprising – often both – as in the costumes he did for *Don Juan*.

Rio Grande and *Don Juan* were in wonderful contrast. The first so full of sun and light; the second so darkly romantic, with its perspective of sombre arched arcades leading to a stormy back-cloth, and its subtle colour scheme of blues, greys, blacks and whites. The costumes he designed for the Masquers were particularly striking, like a dramatic and sinister Commedia

Dell'Arte. I don't think I handled this part of the ballet as well as I wished.

We planned another work together. It was to be based on dreams inspired by opium. The first sketches he made still exist. The subject of the piece produced drawings which had a magical mixture of fact and fantasy. I regret we never did it. I'm sure – in its time – the look of it would have caused the same buzz of surprise in the audience as I remember hearing when the curtain rose on the front cloth of *Rio Grande*, showing a row of houses in the brothel quarter of a southern sea port; the shutters open, to reveal in every window the most wonderfully outrageous tarts. It produced the same kind of buzz – slightly startled, half affronted, half delighted – that greeted Picasso's front cloth for *Le Train Bleu* at the Coliseum in the nineteen twenties.

Costume fittings are usually a tense and touchy time for both the designer and the choreographer. There was no tension with Edward, he remained serene and amiable, making suggestions (never assertions) as to the shape of a neck line, the width of a trimming or the length of a skirt, and his suggestions were always sensible and wise. He understood textures very well and liked to place surprising surfaces together. He was the first designer I knew to combine cotton with sequins, as he did on the costume worn by the Creole Boy in *Rio Grande*. The costume in itself was absolutely simple, white drill trousers, a white linen cap, and a white cotton singlet with the neck and the arm holes boldly outlined in silver sequins. He had a gift for this kind of heightening of reality, which produced a strong theatrical effect. When the dancers carefully followed the make-up and the hair styles – both clearly delineated in his costume drawings – the result was not only splendidly unusual but acutely realistic; again the same *heightened* reality.

I can think of no other painter who so well understood the absurdity and the beauty of people, particularly women. It seems a great pity that every one of the works Edward designed for the theatre has vanished. He did such brilliant things for me, and for De Valois and Helpmann. Wonderful back-cloths and front-cloths – great paintings in themselves – a type of ballet decor which has gone out of fashion leaving very little to take its place.

When you think back and remember the masterful work of Picasso, Derain, Braque and all the other painters who worked for Diaghilev, you realize Edward was the last to carry on this tradition of painting in the theatre.

Working with Edward

NINETTE DE VALOIS

GLASGOW IN THE WAR and in the rain on a winter day. Edward arrives to discuss his designs for a ballet to be entitled *Miracle in the Gorbals*. He is surrounded by plenty of the appropriate atmosphere, for Glasgow is living up to itself and the toughness of life in general. In the gloom of the large old-fashioned hotel I meet a shiny very wet figure. The shine is intensified by the stiff raven black raincoat – dripping with the doubtful blessings of Glasgow raindrops. The face is small and very pale; both body and limbs are crippled from the effects of an advanced stage of arthritis; but with the first gay quibble about the locals and their inherited dampness, the atmosphere changes. Relaxed and friendly everyone becomes and full of jokes devoid of effort or any form of self-consciousness. There was now to be a hilarious description of how he had fallen out of bed that morning and had found it impossible to get up; the indignity of his position on the floor, and the long wait until someone heard his yells. He broke off to giggle over the recollection – and we giggled with him. In retrospect, how we managed to do so I do not know . . . but that was Edward Burra; he carried you along with him, sharing his shrewd, penetrating yet kindly humour – at its worst only as wicked as a friendly mockery. All that life had made him physically suffer was overcome; and eventually reduced to an observation in time, that emerged in his designs for the theatre. His sense of colour awakened our insight and awareness in that direction; and his designs had a boldness and a clarity of purposeful line in them that suggested (possibly) a calm note of defiance. Where did the strength, the resilience come from in this particular draughtsman's line? When you had the courage to let your eye glance down to the small distorted hand you found yourself wondering how it could all happen? Yet it did happen, time and again; a creativity with a supernatural sweep of strength, highlighted by an insight that neatly balanced studies of introversion and extroversion that existed in his outlook and on his canvas.

Miracle in the Gorbals was one of his major successes. Paris loved it when we presented the ballet on our immediate post-war ENSA tour. They wrote – when reviewing it – of an 'aestheticism' . . . 'not *our* aestheticism, but nevertheless one of their own – an English one'. There was little Edward

Set for Don Quixote

missed. I have always been struck by the designs for his street girls in *Miracle in the Gorbals*. He simply could not resist painting the perfect face for each costume. Yes, you said to yourself, that girl could not possibly have chosen any other dress, and she would have hunted for that terrible hat until she found it. Was it all observed, in the depths of Glasgow's Gorbals, by the dimmed lights of those war days? But artists like to be accepted, not cross-examined, and for the onlooker the joy of acceptance without cross-examination is equally gratifying.

Edward Burra played an important part in the English ballet scene – important because it was so British in its approach, its humour, its sturdiness. Even the strange lights of a Glasgow winter, fighting their way through the grey gloom, were not forgotten. They were noted by the artist and went into the corners of 'the Gorbals' stage set, to emphasize moments of exhilaration or despondency, and eventually to convince the French how very 'English' we were . . .

There stands out clearly a special memory: the magic front-cloth for *Don Quixote*. Rarely does there appear such force and spiritual strength in a stage set painting. Every line conveying purpose with a defiance that is highlighted; a fate framed in ennobling colours – whatever the outcome. We do

not get such cloths today in the theatre. Perhaps they would prove to be too great a challenge to what follows after – as was the fate of the 'Don Quixote' cloth. There is also the memory of his final set for *Don Quixote*. The set did all the work; the choreography just sprang out of it and was consequently the best scene in the ballet. The ballet failed, but through no fault of Burra's. Although it met with the approval of Spanish professors in the country and the Critics' Circle (a special group that held forth once a week on the radio), the public and the ballet critics firmly turned their backs. . . . Perhaps some enterprising young choreographer will one day make an effort to tackle that lovely but difficult score, and put those wonderful designs back where they belong – in the theatre.

Edward was philosophical. He did not believe in making trouble, nor was he interested in those who did. Neither did he know anything of vanity. His set for *Rio Grande* (produced at Sadlers Wells in the middle thirties) received a severe rebuff. Awaiting a lighting call, we broke off for lunch, leaving the set in solitary state. On our return we were confronted with the total obliteration of a nude female figure – it had been painted out, by order of Lilian Baylis, as a strong mark of her disapproval. I was filled with a mixture of horror and indignation, but beside me I heard a well-known chuckle, a quip or two, and then the dismissal of the whole matter . . . I think that he found Baylis more of a 'character' than the offending nude.

Yet grim, satirical, and indeed quietly savage could some of his work be labelled. But it was always a passing comment. I never felt that he had any existence or connection within such worlds as he would sometimes portray. An artist cannot suffer as he suffered and not want to comment on it; creativity has its moods, and they must be allowed their full range.

Edward Burra and the Corcoran Family

WILLIAM CHAPPELL

EDWARD BURRA'S close and affectionate relationship with the Corcorans (who, later, were to become his dealers) began when he met Beatrice Dawson who was to be Gerald Corcoran's first wife. She was a plump, attractive and amiable character, very short sighted and given to falling over a good deal. Bumble – as she was known to her intimates – had a strong personality, much more positive than her nickname implies. Her ambitions were equally positive; though, as yet incomplete. She did eventually turn into a highly successful costume designer for the theatre and the movies. Edward met her through Barbara Ker-Seymer – she and Barbara were fellow students at the Slade. Bumble was an assiduous and energetic party goer, and it was not long before she moved into that 'scandalous' set (who were the joy of the gossip columnists) known in the late 20s as the Bright Young People. They were certainly bright; not all of them so young. Charm or style; wealth or talent; even only a strong determination to shock and flout convention, could all act as a passport to this Never-Never Land. Homosexuality both male and female, was modish, so much so even fervent heterosexuals had been known to stray (or pretend to stray) to forward the combined causes of 'chic' and acceptable social behaviour.

It was a potently attractive, lively, and sometimes disturbing, scene. If you liked party going there was rarely a night without one. Gerald Corcoran, young, tall, handsome and elegant, made a decorative addition to the crowd of writers, painters, poets, theatre people, and those affluent enough to have no need to work. To this crowd could be added the expected collection of pretty male and female lay-abouts.

The novelist of the time was Aldous Huxley; the newest playwright, Noel Coward; the most striking actress, Talluhah Bankhead. The Diaghilev Ballet was the rage. The drug was cocaine. The music, jazz. The dances were the Charleston and the Black Bottom. If you were unable to master these, you 'smooched'; which meant clasping your partner as closely and

tightly as possible, and swaying rhythmically in a minute circle on one spot. This was a convenient style for the tiny crowded floors of the night clubs.

Bumble and Gerald had paired off and set themselves up bang in the middle of the tarts' quarters in Shepherd Market W.I. Here Bumble started a business in costume jewellery, belts and handbags. Later she began to encourage Gerald towards the world of the art galleries. Edward had already shown his paintings at the Leicester Galleries. The critics were nonplussed and not knowing quite where to place him, tended to be dismissive.

Gerald started his work as a dealer from his home in Shepherd Market. He bought his first Burra, an elaborate water colour of a pastoral scene with clown-like figures and dancing cows. Tentatively he proffered a fiver (cash). 'Yes dear,' Edward said with alacrity. 'That'd be all right.' Gerald became aware that Edward only really understood cash. He much preferred the idea of £100 in crisp notes to a far larger sum in the form of a cheque. He had no belief in banks, bank statements, deposit accounts or cheques. As far as he was concerned they were all abstractions.

In the thirties, Gerald was working with Matthiesen in Bond Street. He had continued to look after Edward, and had found a small visually alert and far sighted group of collectors who began to buy Burras. Bumble was the instigator of two exhibitions of Edward's work given at the Redfern Gallery. The following extract from a letter written to Edward by Paul Nash indicates that the paintings seen at these shows had caught the attention of a member of the higher echelons of the art world. The letter is undated and briefly headed 'Oxford'. It plunges straight into a parody of a gossip column in a glossy magazine.

'Dropping in for a spot of lunch at the Ivy, I noticed a distinguée little "table" consisting of Sir Kenneth and Lady Clark; the new artistic lovely Miss Mary Kessel, that wizard critic Raymond Mortimer and that very rarely seen painter Paul Nash. A considerable discussion seemed to be going on. I caught a few words occasionally. Someone asked, "Have you seen the Burras?". Astonishing. Incredible. Terrifying. You *must* see them etc. etc. What are these Burras? Everywhere people are saying, "Have you seen the Burras?" "You *must* see the Burras." As I left the Ivy I just caught sight of dainty little Lady Clark getting into a taxi with the artist and the critic bound for the Redfern Gallery (and so on).'

'Well bo' you sure have arrived. It was quite distressing to see Jane Clark trying to buy pictures that were already sold. I suggested quite a few should go to cheer things up among the War artists at the National Gallery. There was a flying blue monster I thought very suitable. It's

almost my favourite. There are some very fine things. I'm very glad you have been dug out at last from your obscurity, but how have you avoided this, or have you?

Poor Raymond couldn't take it at all. 'They're so *loud*,' he wailed to me. Personally I enjoyed them immensely. My warmest congratulations dearie. I hope John R. does a good Penguin for you. . . .'

John Rothenstein (commissioned by Kenneth Clark) did, indeed, do a good Penguin; and, as an early admirer of the paintings he took an active line in promoting interest in Edward's work.

During the war the marriage of Gerald Corcoran and Bumble broke up. After separation and a divorce, Gerald married his present wife Phyl. Their son Desmond was born in 1943. Taking sides was, to Edward, the worst possible bad manners. He continued to visit Bumble and also Gerald and Phyl. The situation was wonderfully amicable. It was quite usual to see Gerald out and about with both his new wife and his ex.

As a small boy Desmond remembers Edward's visits being regular enough to give him much the same status as a favourite uncle. Having just seen his first Western movie *Fort Apache* Desmond was in the grip of a passion for cowboys. He kept a book in which he persuaded Edward to draw over and over again, his interpretations of those godlike gunslingers. Edward was a movie buff and himself a fan of Westerns so it could not have been an arduous duty. Alas, the book has vanished, and no one knows what became of it.

It was Edward who introduced Desmond to the esoteric world of fantasy fiction when, one day, he handed him a book *The House on the Borderland* by a British writer named William Hope Hodgson. By true literary standards, it had little merit and its style (false archaic) was atrocious. None the less this and his other work *The Nightland* are minor masterpieces of horror; sustained by a wild imagination, so inventive, so feverish and intense and terrifying, the scenes and images almost grow out of the page. Desmond became immediately addicted, and he is quick to point out that many of Edward's more dramatic landscapes have aspects culled directly from the writers of this school. Desmond today, is himself a director of the Lefevre Gallery in company with his father and his mother. Desmond's mother is a good and knowledgeable cook. She and Edward would discuss food and cooking by the hour. It was a custom when he was staying with the Corcorans to take him to dine in some special restaurant. On one occasion his visit happened to coincide with the private view party day of an exhibition of his own work. As usual he would not go near the gallery.

It had been arranged that Gerald and Phyl should return home after the party and fetch him out to dinner. The restaurant chosen was of a certain

standing and did not care for its male customers to be without a neck tie. Edward was not partial to wearing ties and arrived without one. The maitre d' was about to pounce, when, with a smile of ineffable sweetness, Edward produced as though from nowhere, a perfectly good tie. There was no doubt at all he had deliberately kept it hidden to provoke the head waiter: but, as Phyl pointed out, the fact that he had taken the trouble to bring it, even though he considered such rules pompous and pretentious, proved he had no intention of allowing pomposity and pretentiousness to interfere with his eating and enjoying a delicious meal.

Between 1952 and 1980 sixteen exhibitions of Edward Burra's paintings were given at the Lefevre Gallery. One approximately every two years. His sister Anne has kept a record of their travels together in Great Britain and Ireland. She has listed the places they visited and the dates they were there. It is instructive to read this list, compare it with the catalogues of the exhibitions and see how unfailingly the splendid results of his journeys with Anne appeared. Sometimes months, sometimes years after his sharply focused eye had taken a landscape into his memory.

It is close on fifty years since Gerald first became Edward's dealer. Friendship and business do not always mingle comfortably. A friendship so long and so intimate as Edward's with the Corcoran family could not help but become one of the most comfortable and secure attributes to his life as a painter.

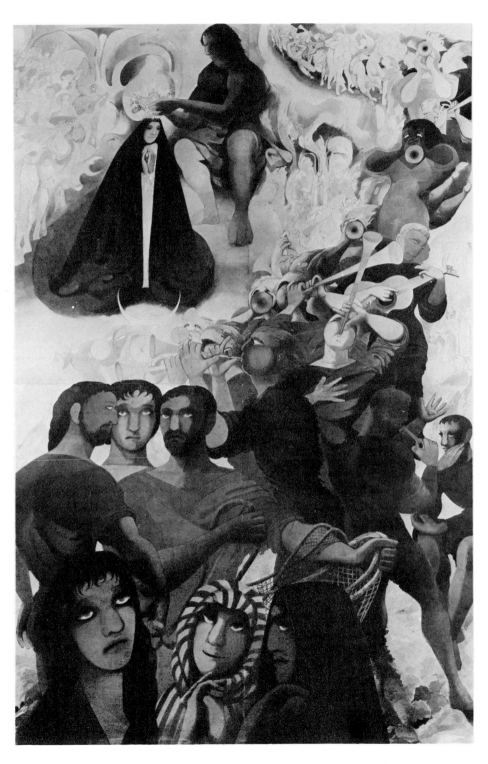

Coronation of the Virgin, 1952: a painting which made a great effect at the Retrospective Exhibition in 1973

The Retrospective

BARBARA KER-SEYMER

WHEN EDWARD had finished a painting he had no further interest in it, he would put it on one side with a pile of others and possibly never look at it again. I wasn't surprised at his reaction when I suggested he should go to the Tate Gallery to see his Retrospective Exhibition in 1973. He said, 'What for? I've seen all the paintings. I know them.' I pointed out that the reason I thought he should go was for politeness to Michael Compton of the Tate who had taken immense trouble in arranging and mounting the exhibition and who might be disappointed if Edward hadn't bothered to go and see his arrangements. Edward was a very kindly person and never wished to offend anyone or hurt their feelings, so he said he would go. I suggested we went late on a Saturday afternoon when most of the people had left and I could park my car outside the Tate so that it wouldn't be any effort for him to go in. He agreed to this and on the chosen day we set off. We were in the Tate and approaching the entrance to his exhibition, when Edward paused and started to dig in his pocket. I asked him what he was doing and he said, rather crossly, 'I haven't got a ticket.' I told him he didn't need a ticket and he said, 'You have to buy a ticket to get in. It says so.' I said, 'Ed, you are the artist, you painted all these pictures. You don't have to pay to see your own paintings.' I had, by this time, shown my pass to the man at the door and indicated to him that I was with Mr Burra and would he let him in without any comment. Edward was still rather dubious but passed in without any notice being taken of him. He walked straight through the exhibition almost without pausing or appearing to look right or left (knowing his eye, and his photographic memory I think he took it all in); he went out of the exit saying, as he left 'Very nice,' and made off in the direction of the exhibition of Paul Nash's photographs. The word must have got round that the artist had been in the gallery as the girl from the sales desk ran after him saying what a marvellous exhibition it was and would he please autograph her catalogue. Ed was very taken aback but I think he was quite pleased and flattered. He signed her catalogue (which was more than he did to most of his paintings).

After looking at the Paul Nash photographs, we made for home. The ordeal was over and Edward could now say that he had been to the exhibition.

The Traveller

CLOVER DE PERTINEZ

MARY AUGUSTA AIKEN

Edward possessed an insatiable appetite for travel. After his painting it was the occupation that gave him the greatest satisfaction. When, finally, the effort needed to take himself abroad became too much, he travelled busily through Great Britain and Ireland as a passenger in his sister's car; finding a variety of material for his paintings, and doing his liver and his stomach less damage than they usually received when he was in a foreign country. In Great Britain when the food was good it was plain: poached salmon, roast beef, steak and kidney pie, roast lamb. When it was bad, it was, as a rule, innocuous; tasteless and devoid of nourishment; only very rarely poisonous.

Considering how ill equipped his poor inside was to cope with the type of dishes he enjoyed abroad, he treated his stomach abominably. He was far from greedy; he had a very small appetite; but he loved the sea food and the great fish soups of the Mediterranean ports; the searingly hot and spicy dishes of Mexico; the clams, oysters and lobsters of the North American coast; the boudin, the tripes and the strongly spiced sausages of Northern France. When alone he was given to eating in raffish little bars and small restaurants on quaysides, where the food was native, rough and cheap. Sometimes excellent, and – occasionally – risky.

The reckless attitude he adopted in so blandly refusing to admit to any weakness in his liver and his digestion, combined with his self-hypnotic willpower, paid off; in that he appeared able to recover – a bit battered possibly but still, to recover – from the bouts of sickness and the dreadful liver attacks he suffered which would have proved too much for characters stronger and healthier, because they lacked the firm mental control he exercised over all his physical weaknesses.

Conrad Aiken, the American poet, and his wife the painter, Mary Augusta, were probably his ideal travelling companions. Intrepid, adventurous, lively; they were prepared to take endless desperately uncomfortable journeys to reach unknown places; to eat the local food and drink the local drink; anything, anywhere, and suffer it. No fuss was made.

In the end Mexico nearly wrote off Edward's liver for good; and he returned to Boston to lie low and recuperate on a spartan diet.

Clover de Pertinez had become friends of the Aikens when they were living in Rye, and she was at High Salvington on the South Downs in Sussex, with her husband Antonio and her baby son named after Edward, who was his godfather. Travelling with Clover in his beloved Spain – almost his favourite foreign country – was different to travelling with the Aikens in Mexico. Clover had a grave respect for her liver (and her digestive tract generally) and was instrumental in guiding Edward – particularly in Barcelona – away from the more suspect eating houses he might well have patronized had he been alone. There is no recorded statement that he had a preference for solitary, rather than accompanied, travel. He went off frequently by himself and enjoyed the complete independence of movement, and the open choice of daily occupations, afforded him by being on his own. On the other hand he also enjoyed – and often needed – company in the evening.

It is abundantly clear that Clover and Conrad and Mary Augusta were good travelling companions.

W. E. C.

Edward in Spain

CLOVER DE PERTINEZ

THE VOICE was the first thing I became aware of. It cut through the snuffles and rasping of throats in the life-room at the Chelsea Polytechnic one November afternoon in 1922. Fog without; fug within. Like many of the students, I coughed a lot. Until the voice declared flatly: 'She needs some Veno's Lightning Cough Cure.' There was a titter. I looked round and traced the voice to a boy who might be my own age – sixteen – sitting on what we called a 'donkey' in the semi-circle in front of the easels. He was drawing, with a line as sharp as his voice was flat, the lolloping Epstein model lady on the dais. I was busy reducing her to a starvation case in the name of Fashion. Veno's is still going, but on TV the 'lightning' is left out.

That friendship begun with hostility lasted until Ed's death in 1976. We were born within six months of each other, in 1905 – he in London in spring, me in autumn, in India. So we were sixteen when we met. Chelsea Poly was under the influence of Augustus John. Raggle-taggle gypsies were all the go. Not for me, though, or for Burra, Barbara Ker-Seymer and William Chappell. We aspired to the smooth chic and sophistication to be seen on the covers of Vogue by Erté and Georges Lepape, to be found in the novels of Ronald Firbank, Scott Fitzgerald, Paul Moraud, Jean Giraudoux, and above all in Diaghilev's Russian Ballets. One visit to *Carnival, Cuadro Flamenco* (with set by Picasso) and *Prince Igor* made me persuade my parents to let me leave school at sixteen and go to art school. At Chelsea Poly we called each other by our surnames and soon Burra, Chappell, Ker-Seymer and Pritchard were a quartet apart from the rest. We shared a passion for German silent films made by UFA and travelled long journeys on buses and underground to the suburban cinemas which in those days, to their credit, showed the *Cabinet of Dr Caligari, The Blue Angel, Mädchen in Uniform, Metropolis* and a lot of lesser German pictures with Harry Piel, Lilian Harvey, Lia de Putti and Pola Negri. The effect of *Dr Caligari* on Ed's painting has been remarked on by some critics. But to understand his work as he would like it to be understood a thorough soaking is recommended from an early age in Baudelaire, Verlaine, Rimbaud, Jules Laforgue, Tristan Corbiere – les poètes maudits. He was soaked in them himself, and a little later on in Spanish poetry: Garcia Lorca, Rafael Alberti, the Machado

brothers, and Gongora for a start. Our Spanish began with that difficult seventeenth-century poet. *'A mis soledades voy, de mis soledades vengo'* ('To my solitudes I go, from my solitudes I come') Ed would quote when asked questions about his movements. He was a master of murmured asides and very secretive about his comings and goings. (One of his expressions in a wry voice – 'You haven't heard the half of it, dearie!')

He hated fuss above all things, and fuss about what was not yet called Gracious Living made him dislike Rye, the historic town where he lived most of his life and which he called Tinkerbell Town, as he also hated Peter Pan and the current craze for not wanting to grow up. I think he liked me because I tried my best to look and behave as if I were thirty and dressed in black when I was seventeen.

At twenty-three I married a Hungarian who had a small estate near the newly-drawn Czech frontier. The post had to be fetched by a farmhand on horseback from the nearest post office, five miles away, so my correspondence with Ed, Barbara and Billy was first intercepted, then prohibited. In 1931 I decided to walk out. Not long before I did so I was allowed to write a letter to the *Morning Post* in defence of Surrealism which was being attacked in its correspondence columns. I was making a snowman or rather woman (the Archduchess Maria Teresa of Austria) in the garden when Janos rode up with the post and before my husband could intercept it, I found a letter signed Ed, Bar and Billy who had read my letter to the *Morning Post*. In 1932 I went back to London, leaving all my possessions behind, but feeling free at last. I found that Burra, Billy and Barbara had gone up in the art world since I last saw them in 1928. Burra had exhibited at the Leicester Galleries, Billy was with the Rambert ballet, Barbara had a smart photographic studio over Asprey's.

That summer of 1932 Ed asked me to stay at Springfield for a weekend. Since then I have stayed with him at his parents' many, many times, until they died in the nineteen-sixties, first his father, then his mother. They were both over eighty. Ed was much fonder of them than he appeared to be and they were most understanding in their attitude towards him. They were always very kind to me and to my second husband, Antonio, and to our son, Edward. After Mrs Burra died the Chapel House at Rye, where they had moved when Springfield became too difficult to run, was sold. Ed moved into one of two cottages on the edge of the Springfield garden that still belonged to him and his sister.

During that summer of 1932 we were excited by the discovery of P. Wyndham Lewis, whose *Apes of God* I had read in Budapest. Ed became a great Lewis fan and read all his books as soon as they came out. He was far less interested in Lewis as a painter. They never met, but Lewis wrote a review for one of Ed's exhibitions when he was art critic for *The Listener*,

which Ed appreciated perhaps more than any other review of his work. He particularly admired one of Lewis's later books, *The Demon of Progress in the Arts*, anathema to promulgators of Minimalism and Abstract Expressionism.

In the autumn of 1932 I went to Paris and Ed went to Mexico with Conrad Aiken who was getting a divorce there from his second wife to marry Mary Hoover, who has survived him. 'He had this mania for marrying,' Ed wrote to me from Mexico. We both came back from our travels rather the worse for wear. Ed looked like a starvation case, in a terrible state of anaemia, a Chinaman's head tattooed on one skeletal shoulder. I was anaemic, too, from not getting enough to eat in Paris which was very expensive then owing to the exchange. During 1934 we often met in Brighton, half-way between Rye and Worthing where I was living with my parents in a cottage on the Downs. We each had a fanatical hatred of these towns. He called Rye Tinkerbell Towne; I called Worthing Smugnor-on-Sea. But we loved raffish Brighton, where we ate, drank and were very merry indeed as we ransacked the second-hand bookshops, particularly for the novels of George Gissing whose brand of pessimism was much to our liking.

In the spring of 1935 Ed suggested that I go with him to Spain. 'I know you'd like it,' he said. 'Even better than France. It's much cheaper and the people are much nicer. You feel it as soon as you cross the frontier. They're not after your money all the time. *And* they're so much better looking.' But his main reason for going was to get away from the Jubilee celebrations of George V and Mary. 'If I hear the word Jubilee again, I'll be sick.' The four-year-old Republic of Spain was the obvious place to go from a country *en pleine folie monarchiste*!

Beacons were alight along the Sussex coast as we went on board the night-ferry at Newhaven. We were almost the only passengers. Everyone was coming to England that spring. But Ed always went against the current. '*La minoria siempre*' was his motto, taken from the Andalusian poet Juan Ramon Jimenez. Ed always was in a minority, a very 'elitist' one, and I think his work always will be, as any artist, however good, could never get his due if he shunned and hated publicity as much as Ed did. He never spoke of his work and hated being interviewed. When a film was made to be shown at his Retrospective Exhibition at the Tate in 1973, he was with great difficulty persuaded to appear. The film was entitled 'Edward Burra, Painter and Recluse'. He was not a recluse at all. He had many friends and was most convivial in company he liked, with plenty to eat and drink. But he did not tolerate people he didn't like. He just refused to see them. And as they were generally people connected with the media, or the Farts Council as he called it, he was called a recluse, rather than exclusive in his tastes. On

'Madame', a drawing of the famous flamenco singer Pastoria Imperio

the night train to Barcelona we travelled third class. I don't believe Edward ever travelled first in his life, anywhere. In spite or perhaps because of being in almost constant pain since he had rheumatic fever at the age of thirteen, he was able to endure uncomfortable conditions, even to seek them out, bodily or mentally. One of his best-loved authors was J. K. Huysmans, whose descriptions of suffering he revelled in. I am very fond of Huysmans myself, but I am too squeamish to stomach *Ste Ludvine de Schiedam*, one of Ed's favourites I have been given by his sister, Anne. As for *Les Foules de Lourdes*, I'd just read that before we started for Spain. I talked about it to the London correspondent of *L'Action Française*, the royalist daily, whom I'd run into in Knightsbridge. He told me he was to write about the Jubilee crowds and I suggested he took a look at *Les Foules de Lourdes*. When Ed and I bought *L'Action Française* at the Gare d'Orsay (which was then the station for Barcelona) we found the journalist had lifted streams of adjectives from Huysmans to describe the Jubilee throngs. Ed's love of Huysmans caught up with him years later in the fifties. He decided to accompany me, as he often did, as far as Paris on my way back to Madrid, after the summer holidays, which I always spent in England with my mother and son, while my husband, Antonio, retired to the bosom of his family in Granada. Ed and I liked travelling by boat and train. I only flew if I had to, but Ed never left the ground except by sea. We went as usual on the night-ferry to Dieppe. On this occasion I had a cousin in tow I had to take to Spain, too scatty to travel alone, and Ed was saddled with a lady he and his family had known for many years and who had never seen Paris. It was a very rough crossing and the ferry could not get into the harbour. For three hours we rocked outside, the ferry crowded with a pilgrimage to Lourdes. There were stretchers everywhere. Priests and nuns ministered to the very sick in both senses of the word. Ed sat sipping brandy from a flask, taking in the Huysmanic scene. He was a good sailor!

In the Fifties another writer had perhaps the strongest influence of all on Ed: Samuel Beckett. He saw himself in those tramps, Beckett expressed what he had always felt about life: 'A long, muddy ditch along which one crawls with another tramp behind trying to stick a tin-opener up one's arse.'

Besides *L'Action Française* we bought *Le Canard Enchaîné*, which is still going, and *Aux Ecoutes*, which may not be. Ed loved scandal-sheets and later on took *Private Eye*. As we sat in our corner seats of the night train to Barcelona, a most beautiful moonbeam of a young man got in to our compartment after taking leave of an older, shady-looking gangster type who was giving him last instructions on the platform. Ed couldn't take his eyes off our fellow-traveller, whose pale-green skin and eyes, and suit to match made him murmur: '*Verde que te quiero verde,*' when the young man

went into the corridor for a last mutter with his sinister friend. 'Green, green, I love you green' in Roy Campbell's translation of Lorca's ballad from the *Romancero Gitano*. We soon stretched out along the seats on that long, hot night journey. The verdant beauty took off his shining patent-leather shoes and his black silk socked feet explored far up my side. A battle of tootsies ensued until we fell asleep. What a look of scorn he gave us in the early morning sunlight as he went off to shave. 'You can't have made the best of that heaven-sent opportunity,' Ed remarked as the moonbeam slid away into the crowded station.

We took a taxi to the Hotel Llorente on the Rambla de la Flores. Ed had seen it advertised in *Paris-Soir*. Very cheap rooms. It was on the first floor over some shops. The reception desk was deserted, in darkness that smelt of tomcats as well as cheese to catch the mice. 'I'm not staying here,' I said. 'It looks too sleazy even for me and it stinks.' 'I am,' said Ed in the deadly voice he used when anyone tried to thwart his plans. His decisions were unshakeable. I have never known anyone so inflexible as Ed when he had made up his mind to do something or more often not to do anything about anything. Like when the Royal Academy rang him up when I was staying with him at Chapel House in Rye in the fifties. He was painting in his top-floor room that had yellowing pages of *The Times* pasted over the windows when the light was too strong. Frederick, the manservant, shouted from below: 'The Royal Academy on the phone, Mr Edward.' 'Tell them to fuck off, I'm busy,' Ed shouted back. They rang again next morning. The same reply was bowdlerized to them by Frederick. 'They want me to go and get my medal,' Ed said, 'and have lunch. I wouldn't mind being an ARA if I didn't have to do that.' But they were adamant and so was Ed. And that is why he never became an Academician. He just couldn't bother to go to town to receive his medal! He only accepted a CBE when told it could be sent to him (and would be useful when barmen tried to turn him out of pubs for looking like a gypsy or a tinker).

So I left Ed at the empty reception desk of the Hotel Llorento and went down to the taxi where I'd left my luggage, just in case. I pointed across the Plaza Colon to the Gran Hotel, which was three times as expensive as the Llorento and looked one hundred times cleaner. Twenty-five pesetas a day included full board. As I sat down to a six-course lunch the pale face of Ed appeared round the dining-room door. Surreptitiously I fed him and even so I had a sick-headache next day from over-eating. We agreed on a happier mean of board and lodging and moved to the Hotel Falcon further down Las Ramblas, opposite the Barrio Chino, Ed's main objective in Barcelona. Franco had it pulled down, imitating Hitler's demolition of the Vieux Port of Marseilles. But in 1935 it was at its most exciting and really dangerous at night. I refused to go there except in the daytime, as I didn't

want to be robbed and stabbed, though Ed said nobody would dream of going for him. So in daytime we looked in the porn and pawn shop windows, and at night went to the Paralelo, that long wide street, brightly lit by the electric signs of small music-halls and boîtes winking away into the small hours. The street was crowded until dawn on those warm spring nights. Ed loved the tiny stages where nudes in diamanté jock-straps pranced and sang in piercing voices. One night we heard a high Bloomsbury voice pipe from the row behind us 'So much beyooteh in such a sordid little place'. This became one of Edward's favourite sayings. Behind us sat some tweeds, woollen ties, rumpled heads and red faces. 'It must be the PEN Club,' Ed said. 'They're having their annual meeting here.' 'I have a bone to pick with the President,' I said. 'As you know, he treated me very shabbily when I was in Paris.' 'You should appear at the meeting, dearie,' Ed said, 'in a blonde wig with a bottle of vitriol.' As luck would have it, when we went to Thomas Cook's in Madrid after our fortnight in Barcelona, to see if there was any mail, I found myself standing at the counter next to the President of the PEN Club, a very short-legged little man with a large portentous purple homburg hat on his large distinguished head. On seeing me he turned as purple as his hat and reeled away from the counter, with a small, grey-flannelled secretarial-looking girl clinging to his arm. 'Tally-ho,' I said to Ed. 'The President has cut me dead. He must be given a fright.' We went after him along the Calle Alcala. He looked round, saw us, and plunged into the traffic. (There was not nearly so much in those days.) He managed to reach the other side, dragging his startled *petite amie*. We stood on the kerb, watching him disappear down the steps of Metro Alcala. 'Gone to ground,' I said. 'What an appalling pompous little person,' Ed said, and referred to him as Little Leggies from then on. We went to a café where Ed drew in black ink on a sheet of its writing-paper a caricature of Little Leggies and his lady-friend, back views bolting down the Metro. We posted it to L. L.'s publishers in Paris. Not everyone is lucky enough to have a caricaturist of Ed's talent to settle old scores at a moment like that! Ed was brought up on caricatures from childhood. The library at Springfield which overflowed down every passage and into the loos, had books of drawings by Caran D'Ache, Hogarth, Steinlen, Rowlandson, Gilroy, Constantin Guys and Sem. Edward looked at them again and again. I remember him telling me this as we walked to the Prado one afternoon.

We went there every day after lunch at the Café de Levante in the Puerta del Sol. There we were taken under the wing of a small, very dignified waiter. He told us he was a Communist. A yellow card peeped out of the breast pocket of his white jacket with *Analisis de Orina** printed on it, but he

* Analysis of Urine.

did not tell us the result. Ed called him the Dictator because he was so firm about ordering us to eat steak and chips followed by wild strawberries every day, with a carafe of *tinto*, red wine, that Ed called *Audenaire*, quoting Conrad Aiken's pun on the name of that poet in vogue none of us liked. We sat on the banquette opposite a fat, middle-aged ugly Belgian couple, who stared at us hard and then started to ask impertinent questions. 'Were we married?' 'No.' 'What hotel were we at?' 'Two different ones.' (This was true, again I had chosen a less sleazy one than Ed's.) 'Why?' 'Because we are English. Anything else you'd like to know?' The Dictator made a throat-slitting gesture with his forefinger and said they must be Jesuits. We each paid our share of all meals, and it took a Communist to approve of such an unheard-of thing as 'going Dutch' in Madrid when out with a lady, even under the Republic of 1931. Those Belgians didn't seem to have heard of it either!

At the Prado we spent a lot of time in the room where Goya's Black Paintings were very badly hung, some against the light, others with the light shining so brightly on the black parts that only the reflections of those looking at them could be seen. One had to dodge about a lot before one got a good view. I expect they are better hung now that they are more appreciated as the precursors of what has become the cult of Black. First, Black Paintings, then Black Comedies and Black Humour in the Arts. But the Spanish government in the nineteenth century after Goya's death did nothing to preserve these paintings. They let the house, La Quinta del Sordo, on whose walls they were, fall into a ruinous state. It took a French Jewish banker, Baron Emile d'Erlanger, to rescue the paintings by buying the house for their sake, as they were wall paintings. He exhibited them at the Paris Exhibition of 1878 and then donated them to the Prado. So that when Ed and I went into the empty room on the ground floor where the fourteen Black Paintings were so badly hung, we were transfixed. For Ed it was like entering the familiar world of his inmost, unspoken thoughts. As Goya had painted the gay, bright world of the Madrid where he was court painter, so had Edward painted the gay, bright world of bars and music-halls of Paris and the Riviera of the Twenties and early Thirties. Then came the Napoleonic invasion of Spain and deafness after a serious illness to darken Goya's vision. The Spanish Civil War and increasing ill-health revealed the tragic sense of life in Ed that had long been latent in him. He sensed the Civil War in the air a year before it broke out in the summer of 1936.

We spent much of our time outside the Prado at second-hand bookshops and street stalls. Madrid was full of them in those days. We discovered Ramon Gomez de la Serna, so famous in Madrid by then that he was known simply as Ramon. In his book, *Pombo*, about all the artists and

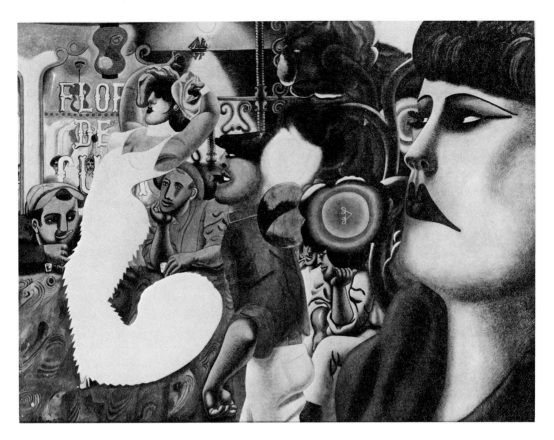

Spanish dancer

writers* who went to that café behind the Puerta del Sol, since pulled down, we discovered the painter José Gutierrez Solana, who was then living in Madrid and had been launched by Zuloaga and Ramon, who had written a biography of him in Vol. I of *Pombo*, but we could only find Vol. II, in which Ramon wrote at length about him 'very differently to the long biography in Tome I.' For by this time Solana had moved to Madrid from his native Santander and had written a book, *La Espana Negra*, which could be translated as 'The Seamy Side of Spain'. Brothels, bullfights, doss-houses, the processions in Holy Week, waxworks in a museum, slum carnival scenes, demolition of old houses, beggars round braziers: subject matter that became very dear to Ed on his return to Rye.

But for the rest of his stay in Madrid we continued to go to the cinema

* The writers included those of the *Generacion del '98* so little known outside the Spanish-speaking world: Pio Baroja, Ramon del Valle-Ynclan, Unamuno, Angel Ganivet, Azoin, all of whose works Ed and I steeped ourselves in.

after the Prado, to ease our aching limbs, and then after dinner, to music-halls and the Circo Price which had Flamenco at irregular intervals that went on into the small hours. Edward had been to bullfights with Conrad Aiken in Granada and in Mexico. He enjoyed the spectacle and had no Anglo-Saxon qualms about cruelty to animals. I didn't go with him to bullfights in Madrid. He went alone once or twice, wearing the green suit he had had made in Madrid. Later he did some bullfight scenes. Other pictures in the Prado that Ed particularly liked were Breughel's 'Triumph of Death' and Hieronymus Bosch's 'Garden of Earthly Delights', and a small blue landscape by Patinir, whose religious subject is scarcely noticeable in the mysterious rocky panorama. He also liked Tiepolo's free handling of clouds, trees and figures. The austerity and sharp outlines of Zurbaran's still-life had a strong influence on his own still-life paintings. He liked Ribera's leathery saints, whose models are said to have been criminals from the Naples underworld. (The great Mexican muralist, Diego Rivera, had also influenced him.) The religious subjects painted after the visits to Spain are not exactly devout in feeling. 'Judith and Holofernes' and 'Money-Changers' gave scope for Ed's love of drama and melodrama. His attitude to religion was as disconcerting as Huysmans's was. He had Huysmans's strong belief in Evil. After reading *La-bas* in the early thirties Ed took a deep interest in the occult, which became stronger towards the end of his life when he enjoyed horror films with vampires and ghouls. The Blue Devil rampant in the world Ed painted just before the outbreak of the Civil War.

He left Madrid after a second visit in the spring of 1936 because he could feel this evil everywhere, and he did not return until the Fifties when he went for a short holiday to Barcelona with Barbara Ker-Seymer.

In 1947 he was asked to do the sets and costumes for Bizet's *Carmen* at Covent Garden. He had always been immensely tickled by the French attitude to Spain expressed by Prosper Merimée, Pierre Louys, Théophile Gautier and Maurice Barrès. I have a copy of *Du Sang, de la Volupté et de la Mort* on whose dust jacket Ed wrote 'scrumptious', putting in a nutshell the fiesta spirit in which these writers described Spain as eternally '*âpre et douloureux*'.* All rocks, brigands, toreadors, gipsy dancers and saints tortured by the Inquisition writhing in El Greco's flames. So Ed was able to parody all this in the splendid sets and costumes he did for *Carmen*. He gave me some costume designs which had been rejected, I believe, as too *âpre et douloureux*, and, indeed, the intensity of the two *gitanas* and their *tocaor* (guitarist) make them far more than costume designs.

* bitter and anguished.

I end these reminiscences with the final lines from Rafael Alberti's poem to Goya from his book *A la Pintura*:

> *Pintor*
> *en tu mortalidad llore la Gracia*
> *y sorie el Horror.*
> (Wit weeps and horror smiles
> in thy immortality, painter).

A suitable epitaph for the painter from Rye, spelt Wry (he loved puns, specially when things were going awry).

The Best Painter of the American Scene

MARY AUGUSTA AIKEN

SIR JOHN ROTHENSTEIN: Well then, who *was* the best painter of the American scene in the thirties?
CONRAD AIKEN: An Englishman.
SIR JOHN ROTHENSTEIN: Who?
CONRAD AIKEN: Edward Burra.

(A conversation during a voyage from Southampton to New York in November 1939.)

'The breaking waves dashed high on a stern and rockbound coast,
The woods against a stormy sky their giant branches tossed.'

THIS IS FROM A POEM I had to memorize at about age seven as to how the sturdy, not so pure Puritan English Pilgrims were greeted by America in 1620, which was just about the same reception which the English painter, Edward Burra, received on the occasion of our first meeting in Charlestown, the Bunker Hill section across the Charles River from Boston where his little Holland–America transport steamer docked in early January, 1937. Doubtless sturdy, and pure after his fashion, Ed's personal appearance was electrifying, as if from an undreamt amalgamation of 'classes'. This magnificent, classic, highly bred English head – alas, quite yellow and green from SS *Atlantic* bars and food – was as if pinned onto a slender small body with gnarled hands, the ensemble wrapped in a flapping top coat which was slit halfway up the back – Mack the Knife? – and might have originally had six buttons, though only three were left. The feet were in some kind of cocoons, something the British call, or called 'plimsolls' – rather like US basketball shoes. Little did I guess that this was to be his costume for the entire winter. He had a small suitcase with him, but nothing in it except a roll of watercolour paintings and a few pairs of socks. There were no shorts, no shirts, no pyjamas. And if that isn't sturdy, I don't know what is. He did have a hair brush. The reason I remember that is because he usurped the so-called party-comers' 'retretto' as his

bathroom, and once our mutual best friend, Gordon Bassett, on emergence from same, sat down to his half imbibed martini, and quite thoughtfully said, 'You know, Ed's hair brush? – well, it GRUNTS'! Speaking of usurping, we lived in an extremely 'pretty' inside, classic outside, brick house, built at the end of the seventeenth century, or earlier: small, four storeys, dormer windows, with a garden and pergola at the back, just off Monument Square. Ed was to have the south top dormer room for sleeping etc and the north one for painting. There was a splendid small view of the Charles River docks, including the Savannah Line, the Navy Yard, the berth of the old USS *Constitution*, which Conrad's ever-so-great uncle, Joseph Claghorn from New Bedford had designed – 'Old Ironsides' – and the old North Church spire, and Boston. Which, however did not keep Ed 'up there'. After ten days' recuperation from his Atlantic trauma, and considerable exposure to American gin and beer at O'Neill's Café, where every fourth drink per person was 'on the house', and which – apart from the mathematical and politesse problems that fact presented – was full of the most fascinating hoi-polloi en masse one could imagine, Mr Burra was found painting on our dining-room table and we were relegated to the kitchen. So! And to go back to 1620 and those Pilgrims, Ed did just the same: took over the uncouth savages, Conrad and me, and had the best of it, which didn't keep us from being a very happy triumvirate, because he was such a damn good painter, and a great help in the cookery department. I think he finished a painting he had begun in England, but the only one he did that encompassed his beginning feelings of orientation in that particular place was a large watercolour, probably twenty-five inches wide by forty-five long, of an enormous lobster consuming a naked male, with an absolutely exact rendition of the view across the Charles to Boston and the Old North Church behind them. In other words, the view from our south dormer window with a Burra conception of what's to come in the foreground. Henry A. Murray, Director of the Harvard Psychological Clinic, planned to buy it but didn't, and I don't know where it is. I wish I did. Ed must have taken it back to England.

But winter or not, freezing or not quite, we soon took to crossing the Charlestown Bridge over the Charles to Boston, and its bars and charms. We were always on foot, not a car or money for a cab between us, and we nearly always stopped, once over the bridge with its ferocious gales, at a nameless little joint for a fifteen cent 'kick-in-the-pants', as Conrad called it. Fortified, we took to the serious business of the night, with Conrad striding ahead as if to crush all traffic, pedestrian or auto, me tagging behind, and Ed, painful feet *et al.*, an unwearying third. I became swivel-eyed being in the middle, trying to keep an eye on Conrad in front and Ed ten paces behind in the frost-bitten crowds pushing with us, or against us,

and neither I nor Ed had been informed as to which hole in the corner would be the next stop. What a Ring Master! Usually it turned out to be a 'sincere' bar, where people, just anybody, came because they really needed a drink: it was called the NIP, and we sat on stools at the bar and had martinis and got warm and loved it, its bartenders, its patrons. Nicest of all, it was just around the corner from the long flight of marble stairs to the Athens Olympia, alias 'The Greek's'. There Ed was blissfully happy and warm, not because it was the pre-natal ooze of the 'Harvoids' intelligentsia', but because of all those loving foreign-faced waiters, looking like violinists in a symphony, and that is, indeed, what they produced for you on your plate, or in your glass.

Thus soothed by oysters or clams on the half-shell, or shrimp, lemon-oil, lamb with okra (or OKRÁ, the beloved country as I christened it for the benefit of Jack Sweeney), or à la Grecque, or sweetbreads en brochette, and café metrios, we sallied forth for the evening's 'serious' business, usually in the company of the Bassett, or Jack Sweeney of Woodbury Poetry Room (Harvard), but once even with Mr T. S. Eliot and wife Valerie, after Tom's award of the Silver Bowl, presented by Harvard's Signet Club. Valerie delighted us by saying she thought she'd have a 'soft' drink, an old fashioned – which is a 'hard' drink if ever there was one, being whiskey or bourbon poured over ice and an orange slice. All of which enchanted Ed as we drank our ten cent beers, and revelled in the heterogenous revellers at the block-long bar, the three bands and four dance floors of the Silver Dollar Bar. Ed kept peering down the aisles – if you can call them that amongst the sailors, and the 'toughs' and the Boston-Irish-low-bracket-politicos and dames – dames of every age, colour and 'get up' – looking for the dwarf to show up, hoping he might touch him, or me, or one of us. Ed said it would bring you good luck! He must have had a gypsy ancestor way back, or else just liked dwarfs as much as Velasquez did. Then, if not too sated – saturated is a better word – or, if only to postpone the long freezing walk back to Charlestown, we would go on to 'Izzy Ort's', which particularly pleased Ed because it had a most unusual bar. Instead of the bar having mirror and bottles behind the bartenders for the patrons to stare at their own faces, this one had – at a slightly higher level – another group of imbibing customers, which made it very easy to lose one's identity and bring one into focus with the others' sins, or charms, as the case might be. One other nearby bar occasionally lured us. It was done up in a sort of Boston Irish tavern-keeper's notion of the romantic South Seas. It was a weird place, frequented mostly by the middle-aged, out for a 'night-on-the-town' or seeking the fountain of youth. For, in spite of its false palms, sunsets, hooch, beer, Jelly Roll Morton or Satchmo jazz, booths and hand-holding, knee-rubbing, and ladies in waiting for the dough-re-mi

from a customer of the evening, there was sorrow, not to mention fear. It was a mystification, so we sometimes returned just to see if any one of us could explain why we all had this strange sensation there.

Then there was the famous Old Howard, the burlesque theatre which began life as a church, where a bit of the old rose window could be seen above the top balcony, perhaps so the angels themselves could peer *down* to far below, and partake of the joys of the long 'run-way' where the men could look *up* from below at the legs, bottoms, bosoms, bobbed hair, and beaded eyes of the G-string Eves from the Garden of Eden, while the 'strippers' took off everything but the tassels from their rotating nipples, and the 'comics' toyed with their yard-long sausages, dropped their trousers, fell over their feet and foot-long cee-gars, smashed their straw hats, and played ring-around-a-sausage with the 'cuties' as they pranced or sidled onto the stage, or made desperate dashes for the wings. O Where O Where can the Puritans be in the 'thirties' of the Twentieth Centuree?

After whichever or whoever, especially fun with Walter Piston, the composer, and greatest punster of all time (though Conrad was Walter's prime sparring partner, winning at least one out of every three rounds) we glowed our way back to Charlestown, like glow-worms through snowdrifts, taxis, squawks, yelps, red and green lights, the fury of gales on the long Charlestown bridge to the safety of the old brick house, and so to bed while visions of everything danced in our heads. Oddly, though typical, Ed didn't do the Silver Dollar Bar etc paintings until after he returned to England. What a memory – photographic – they couldn't have been more 'like'! Especially of the essence, which only Burra could do. We're lucky they exist, especially since the bars themselves are gone forever. I shall always miss them, and thus be more than grateful for the paintings, a lost juicy slice of life as it will never be lived again.

All this time Conrad and I were working for the WPA (Works Progress Administration, created by President Roosevelt to solve the basic needs of artists, among millions of others, during the great depression, in return for work in their particular field, most of which was turned over to US Government ownership). I was on the Artists' project and Conrad on the Writers', salary about $94.00 each per month, and Ed was a sort of PG, sharing household and food expenses, and grateful we were for it too. Conrad practically wrote the Massachusetts Guide, since most of the writers were left-wingers, the fashionable thing to be, if not actually 'Commies', whose chief idea was to turn out as little as possible in order to raise the so-called money per hour's work, or perhaps they weren't really writers, merely 'rabble rousers'. Who ever heard of a writer, author, being paid by the hour? As for me, some of my best paintings are somewhere in some Government office, or cellar. I'll never know.

However, all this while Conrad was trying to get a divorce, but the laws for same in Massachusetts slowed everything down by complications, so, on the advice of a Harvard classmate, now a brilliant lawyer, we were sympathetically advised to go to Mexico to get Conrad divorced and us married in the same Mexican state, Morelos. As Alex said, 'marriage laws are never questioned, if the marriage takes place legally, where the divorce has been legally granted'. Thus, with a 'hoot and a holler' at Massachusetts we set off by train, day coach all the way – couldn't afford Pullman sleeping quarters. And, of course Ed came along. What heaven he thought it would be! Well, to quote the old salt from Maine, 'it 'twan't'! But it certainly had its *Moments*! First, at midnight, when stopped outside the Albany, New York station, the sleepy conductor roused us to tell us that if we wanted to go south to St Louis and Mexico, we'd have to change trains here and now and *hurry*, because this one was going west to Chicago. So, grabbing our luggage, we stumbled into the trainyard's pitch darkness, with just a few car windows lit to guide us, and in our usual duck procession careened past the terrifying, panting-to-start, gigantic engine, crossing just two feet in front of it, thanking the powers that help the helpless for every second it didn't start. Never was the distance so great or so frightening between two steel tracks. Then there was the long exhausting walk alongside the waiting train on the other line until we found an open door to a coach, into whose horrid green plush seats we sank without a word, or even a sigh, asleep.

We woke to a glorious technicolor landscape of blue, red and green. The blue was a wide river, the red a clay red of newly ploughed soil, the green what appeared to be heavily matted short-stemmed large leaves. Our amateur guess was that it was the beginnings of an early tobacco crop, all a lovely rolling patchwork quilt, which we felt we deserved after the frightening black night. Soon we left that river and the train started over a long bridge crossing another one, tawny, going north and south, which we guessed must be the Mississippi – which indeed it was because the train pulled into a station, whilst the conductor shouted, 'All out for St Louis'. 'Meet me in St Louis, Louis, meet me in the square!' So since we had five hours in which to explore, we checked our luggage, and with his usual unerring judgement for the juiciest joints in town, Conrad went straight toward the river where he could see the old stone warehouses, and the coroneted smoke stacks of the old paddle wheel boats, decaying, but more real than Cecil B. DeMille. Ed and Conrad were ecstatic, as they walked to the water's rather grisly, bubbling edge where it met the long, sloping cobbled levee. To our horror, Conrad dipped his finger in the water, and then licked it, gurgling, 'Aha, the Great Divide and I have met at last'. Miracles do happen; he didn't die toot sweet and sour of a mysterious

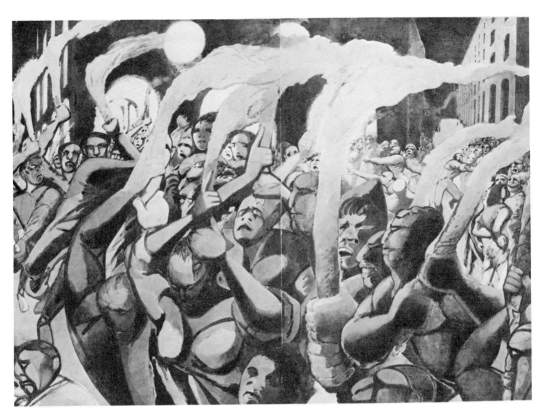

The Riot, painted in 1948 when Burra was in the USA

malady. Quaking as to what next, I followed them up the levee through the collapsing-roofed warehouses. Then what should we see but what looked like the old marquee of a vaudeville or burlesque theatre, with twin golden painted, wooden, bosomy, belles. Grecian draped below the naval, one on each side of what was probably the original proscenium of the stage. There was a menu card stuck into what doubtless had been a box office. Food, drinks, beer and wine! Gawd Almighty! Saved at last! Naturally, we took our starving appetites inside, very queer and dark, but a nice waiter sat us at a corner table, brought martinis, and then a strange but quite delicious mixture of rice, black-eyed peas, pork chops, sausage, and some kind of 'greens'. A curious quiet prevailed, but as we became accustomed to it, and the dim light, we saw that a lot of other tables had murmuring customers, and then we noticed that they would disappear out a back stairway to return soon for a drink. What a setting! It was like living in one of Ed's paintings. Oddly enough, to my knowledge, he never painted any part of the whole delicious St Louis episode, except that so many of his paintings are *like* it in part, that I feel its effect. Nothing was ever lost or wasted by Mr

E. J. Burra. And SO! Hot, dirty, worn out, but with Great Expectations of the Great Divide sated, our duckling-like parade found again the trainyards and this time were treated to ancient red plush, crumbly seats, with great vistas of spring green, mud-speckled creeks and giant skunk cabbage to the west and the east, as the train roared south toward that there Lone Star State of Tex-ass, and the setting sun. We couldn't see the land, which, if there, was horizonless. Just derricks, black, Eiffel Tower-like against the sinking sun, will-o-the-wisps of sky-licking flames from burning wells which became brighter and brighter, as the blue-green pinkish light was shrouded by the descending dark, and soon there was nothing left but the dim light of the railway coach, ourselves, and its other suffering, rather glum co-habitants. Ah, sleep, sleep, beeyoo-ti-full sleep, where art thou in this unending sound and dim light and contortion of uncomfortable, encumbering limbs. Where was Old Will to knit up the ravelled sleeves? But, at last, sleep came while the engine whistled Bach in our heads, and Ed dreamt of coroneted steamboats.

Next day, wonder never ceasing, there was the Rio Grande, and Laredo, where we again had to scuttle through the trainyards. We went through customs, and climbed aboard the train for Mexico City. I suppose we could have considered ourselves in Second Class coaches, since they certainly weren't Pullmans or First, and because other coaches we walked through exceeded anything any of us had encountered in Italy, France or Spain. For sheer glory of human and animal noise, Naples and Barcelona were left in the back row. Baby pigs, baby humans, roosters, hens, dogs, and puppy dogs, peons, peasants of all ages, shapes and sizes, sitting on or lugging bags, baskets, aprons full of bread, sausages, beans, corn, dead and live rabbits, serapes, pottery, alparagatos, alparegos, and everybody and everything that could yelling, laughing, screeching, crying at a pitch aimed to out-sound everyone and everything else. The seats, and their backs were slatted wood, so that everything small enough to crawl under or over, or in between never had such sport! Probably the only quiet things were the scorpions, tarantulas, and viperos, which to the Mexicanos are like house-flies to the gringos up north, i.e., everywhere. Finally we reached a coach whose conductor said it was the equivalent to our ticket rating, and settled ourselves for the long haul to our midnight destination, Mexico City, which would be the next day, since it was nearly nightfall then.

The next day was dreamlike, partly from exhaustion, but mostly because of the pure but frightening landscape's beauty, a marriage of nightmare and symphony. The train whistled shrill and clear at every dirt path it crossed all night, so the dawning sun found us staring transfixed, as it poured through the crevasses between the singularly pointed, barren, mile-high mountains upon the nearly desert-like land on the plateau

below, where the squat walled adobe villages, each with its domed or turreted little pink church, guarded by the date palms (which somehow managed to give the appearance of the Spanish Guardia Civil, as the sun's rays turned them into black silhouettes), while here and there an awakened peon wrapped tightly in his serape, lounged against a sunlit wall, waiting. The villages were far apart, and we went through or stopped at a few old semi-walled towns. Monterrey, St Louis Potosi, where we could get off the train to be beseiged by Mexicanos or Indians selling all sorts of strange wares, some best not gone into here. Ed was 'epaté-ed': such sights, such smells, no cars, pure heaven compared to motoring.

Soon the train puffed harder and harder, must have been an old engine pulling it, as it began the long climb to the high perimeter around Mexico City. The sun went down Zing! in a last glorious splash of saffron, aquamarine and tangerine leaving a deep black blot outside our windows. The engine soon stopped its warning whistle, so we gathered we were far above any habitations of man, as the slow clickety-clack of steel wheels began to quicken. We must have just crossed the high of the journey and were finally starting to relax and even nap, when we were swiftly shaken out of any peace of body or mind, by the old engine gathering speed, racing round curves so that the coaches tilted just like those of a giant roller-coaster. We hung onto our seats, for our lives, or anyway limbs, depended on being upright. Fast, faster, fastest went the engine whose brakes must have given out decades ago. We all turned green, and I feared we'd burst right through Mexico City station and hurtle into Yucatan and Aztec lands to an early grave for us all. Well, we didn't! The flat plateau was reached in time, the engine began to slacken speed of its own weight, scattered lights appeared to left and right, and then streets, houses, lights and more lights, and a 'people' noise that could be heard above the train's own. Could it be midnight? Why weren't people in bed asleep? It *was* midnight, but to a Mexican that means everything but BED. We had arrived!

We found a cab, whose driver frightened us as much as the train's engineer, to take us to the Hotel Canada which was to be our residence until we found a divorce lawyer, then started walking to find a 'bite' for our famished appetites. Everything was wide open. Boston was never like this at one a.m. We had our first tequila con limone, and then the bite, so hot it must have been prepared in Hell's Kitchen, which sent us staggering back to the hotel. Conrad promptly got ill at both ends, and in the middle too; I think he had a mild heart attack from reaching that high altitude so swiftly and leaving it even faster. This kept us both out of commission for a few days since I had to look after him, but Ed had a field day exploring the whole of the downtown, the endless churches and bazaars, but most of all he was entranced by the huge Cathedral, built out of roseate red crumbly

volcanic rock, and inside a glorious entanglement of delights, smells, sights, sights, lights, from votive candles to stained glass with the sun streaming through, endless chapels with iron grill-work protecting the tomb of a saint, martyr, or hero, with a wooden carved statue laid on top, every detail painted as realistically as possible, sandals, loin cloths, curls, lips, nostrils, eyebrows, toe nails, all bleeding wounds pouring with red painted blood, and the Virgins in their golden-starred-and-mooned blue-and-white robes, halos glittering gold, and the Christ child, all tinted, rosy cheeks, bright black eyes, and tiny, tenderly pink-tipped penis. Ed's revels there will never be lost, because as soon as he returned to Rye, he made a large painting of one of the chapels done from an amazing perspective view, and including, with the figure on the tomb, all the surrounding bric-a-brac and a total ambience so extraordinary, that it was as if one could see and be the whole interior of the Cathedral at the same time. What a genius! to do it all from memory, while in the staid rather formal confines of the Burras' manor house. As always, I wonder where that painting is now, and if its owner realizes that he 'owns' the Mexico City Cathedral?

However, I *do* know where the drawing is that came from that fabulous train trip. It is now mine, all mine! Ed gave it to Conrad and me when he finished it after we returned to Jeake's House in Mermaid Street, Rye. It must be the largest pen and ink and wash drawing on earth, being approximately 54 inches wide by 84 inches high. It is the landscape of that dawn we awakened to the sunrise glimmering through and over the mountains onto a village on the barren Mexican plateau below. The sky, mountains and village are at the top, and have an ominous feel about them. Then in the foreground is a large peasant woman, wrapped in a serape and ragged shawl, like a squatted Fate figure, stirring a large flat-lipped pot containing fleshy bones, set over a small fire. Her face is expressionless, as only an Indian's, or someone's without hope, could be. Not glowering—merely being. Looking on, with a prayer in its piteous eyes that some morsel will, by an unhoped for good luck, come its way, is a mongrel bitch with great swollen dragging teats. Mexico: it is all there. Conrad remarked that the structure of the bones in the pot looked much like the skeleton of an infant. I wonder. Ed didn't deny or affirm.

Among the Mexican lawyers we interviewed we couldn't find anyone who could take Conrad's case then and there; they were all too busy or self-important, but a kindly American recommended that we call his friend, a Mexican lawyer who lived in Cuernavaca, about thirty miles away, up in the mountains, a sort of resort place for Government grandees, and those who wanted to get away from the big city in the summer. Nothing could have suited us better, because Malcolm Lowry, Conrad's pupil since he was nineteen, and to whom Conrad had been *in loco parentis*

for the past eight years, was in the throes of finishing his novel *Under the Volcano*, while actually living as nearly as possible underneath it, Popocatepetl, with his wife Jan Gabriel, in a long verandahed cottage with a big garden, mostly jungle, next door to the summer residence of the British Consul. The Lowrys had a postage stamp swimming pool, the Consulate a tennis court, and it was at the very bottom of a sinister walled, unpaved street, called Fernando el Catolico. Malc had been begging us to come visit them as soon as Conrad sent him a postcard saying we had to go to Mexico. Doubtless he hoped we'd come as paying guests because he was perpetually broke. His monthly allowance from his father went from Scotch down the line through tequila and habanero, to end in the peon drink, pulque (made from cactus and about a centavo a drink). It was a crazy place, too fantastic for me to go in to here. I know Ed liked it, but felt trapped, and Josefina's cooking was not the best for an enlarged spleen, a tender liver and the arthritis, left over from Ed's attack of rheumatic fever. I'll never forget the afternoon I looked into the pot on the charcoal stove and saw a whole rabbit, ears, eyes, teeth, toenails, cotton-tail, all in its fur, slowly swirling in the barely simmering water. When I asked Josefina why she didn't clean and skin it before she cooked it, she simply said, 'Very quick, very easy this way, all come off pronto in time for dinner.' No argument there, so I wakened Conrad and Ed from their siestas, to prepare for the long walk up Fernando el Catolico to the Playa Centrale where we would partake of the pre-prandial drinks at 'Charlie's Place' opposite the old Cortes Palace which by this time had been somewhat modernized by the frescos of Rivera, and was next to the bus station where the clarine in its cage shouted its descending scale, to rise to crescendo shriek as each bus came and departed. I suppose I shouldn't have done it, but the terrible tequila con limone was too much for me, so I poured out my lurid description of the furred rabbit in the pot to be our dinner that night, and that, I fear, was the end of Mexico for Ed, who for the past few days had been a bit green and yellow round the gills. Too much for the sky too, which began to darken ominously, with great thunder-heads of clouds blotting out the twilight, so we high-tailed it out of there, and stumbled, in our usual procession, as fast as Ed could make it over the rough road to the Lowry gate in the wall, across the jungle garden and the little ridge over the sewage canal and onto the verandah just in time for the first bolt of lightning and its attendant thunder-clap to put out all the lights, and then the deluge from above drowned out everything while we hunted for flashlights and candles, praying that the scorpions would stick to the ceiling rafters where they usually stayed put all day. The less said about the dinner the better. Jan was away visiting the silver mines, and The Malc simply didn't appear, lost in his favourite bar, we assumed. The lights went back

on, so we went gingerly to bed, studying the sheets, pyjamas etc for stray scorpions, black widow spiders, or any other dangerous wild life. Trying to sleep, lights out, we heard groans and 'Help, help, please, are you there Conrad?' from the garden, so nothing else to do but go to the rescue. Conrad found The Malc, plastered, but also plastered with mud because he had fallen off the little bridge into the bilbo (sewage) canal, desperately trying to claw his way out of it. It was a long night, and the last with us there for Ed. We had to stay to finish the divorce and marriage, but he gave up poverty and ordered a car to take him to Mexico City, where he got on the first train to Boston and our house in Charlestown. He was really ill.

It was a tremendous relief to get a letter from him about a week later. We were worried that he might not make it, and also what would happen to him, ill and alone, in our house. But with his ever present tenacity and bravura of spirit he phoned our good friend Gordon Basset, to plead for, of all things, oysters on the half-shell and company. The faithful Bassett (to whom we had written of Ed's abrupt departure for Charlestown) went to the old Union Oyster House, a Boston landmark, and, fortunately on the way to Charlestown, had them shuck a dozen oysters, pack them in their deep shells flat in a box so that he could carry them over the bridge to Ed, without spilling a drop of their precious juice. Then he went next door to alert our fine fat Irish neighbour, Mrs Curran, who helped me with the house-cleaning, and who was a prime example of the wit and good humour of the Charlestown Irish, not to mention her kindly affection for our odd trio. Perhaps *nothing* is *odd* to the Irish. Next day she promptly took over, and as Ed later reported, fed him on Irish tea, which as she brewed it, he said would have killed or cured a dragon. So, between her morning administrations, and Bassett's excellent conversation, stimulated by oysters, he stayed alive to greet us when we arrived from Mexico, wedded at last, and therefore presumably respectable, although nobody seemed to notice. *Tant pis*, is all I have to say after all that struggle. Obviously Beacon Hill, Cambridge, even Belmont and Concord had considered it a *fait accompli* ever since we met on, of all dates, Harvard's 300th Anniversary.

Edmund Quincey had returned from Portugal to claim the little house, and we had to get Ed back to England as soon as possible, and at home with his family in Springfield. Conrad was longing to get me to Mermaid Street and his beloved Jeake's House in Rye, so we took the first little Holland–America line ship available. I was the only one who wept when we left. Probably The Bassett did inside too. I still mourn O'Neill's cafe on Chelsea Street, in Charlestown, and the beautiful waitress, Betty, who could make change out of her apron pocket without even looking at it. We must have docked in Southampton about mid-August '37, and so to London and the Brise Restaurant, where Dame Laura and Harold Knight, and Paul Nash

(an unlikely combination for the art world, but all Conrad's close friends) met us for dinner, while Ed took the first train to Rye instead, still in his bedroom slippers and reeking of Sloan's liniment, meant for horses and athletes alike, but soothing also to Ed's swollen joints.

From that time on, both in Rye and America, Ed was so in the habit of being with us that he joined us for at least part of the time wherever we went. He was with us for a whole summer at our old farmhouse in Brewster on Cape Cod, where he painted assiduously every morning, subjects that had nothing to do with where he was. I learned a lot about his technique, which turned out to be rather like fresco painting when a fresh wet section of plaster is applied to the wall, and work has to be finished completely before the section dries. Ed pasted together sheets of fine Whatman water-colour paper until he had the size that suited the painting which was already a *fait accompli* in his head, or 'mind's eye'. He always worked sitting down with the paper flat on a table. In Brewster it was a card table in his bedroom; the painting, being larger, had to hang over the side and front. Next he drew in pencil as much as he could conveniently reach, using very little shading or indication of what was to be dark, and what light. This he then painted, using small plates or clam shells to contain the colours, and a large plate to mix a bit on – though he seldom seemed to mix much. I once had the courage to ask him what liquid he mostly used (he had a jar of water to clean his brushes, of which he had far less than most painters I've known) and he looked up at me sideways with the inimitable Edwardian leer, and said 'spit'. Once one knows that, it is easy to see why his rendition is so deep, opaque, more like egg-tempera. Section by section he finished the painting, never retouching or changing in any way the already completed part to adjust it differently to the latest part he was working on. *Et voila!* Finished! We pinned it to the wall in the music room, where it generally 'knocked visitors for a loop'. At any rate, it gave them something to talk about, if they were able to digest it. The subject was one of the typical lurid Burra dream types. In what looked like the architecture of a Spanish, or even Mexican, palace were steps on the left on which three sinister, robed, hooded, fate-like creatures were conspiring, one of them very much resembling the artist himself. Off to the right was their objective. It consisted of a huge pile of gold coins, money! On the peak was an ordinary porcelain chamber pot, *vaso de noche*, or *pot de chambre*, complete with turned rim and handle. Squatting on this, as seen from a very buttocky rear view was an outrageous reddish-blonde female, sporting a tremendous bulbous, pendulous nose, the kind one sees on males in the comic strips, and highly conspicuous, since the upper part of the body and head were turned in profile toward the supposedly enslaved audience, from whom came the pile of gold shekels. The painting just fitted ths space

where it was hung, and certainly enlivened the music room, and Ed simply left it there in all its glorious sinister technicolor, and I still have it, along with several others.

It was during that summer, '49 I think, that Ed had his exhibition at the Swetzoff Gallery, Newbury Street, Boston. He had brought a roll of paintings with him to our house, and at some point we drove him and paintings to Boston to show to Swetzoff, who was highly enthusiastic and wanted to exhibit them as soon as possible in the early autumn. Ed stayed at our house as long as he could work in that bedroom, which alas wasn't heated, anf there was nowhere else heated where the light was right, so he found a room in Boston near the Red Lion Grill and Harvard Club and The Bassett. The show went on at Swetzoff's, and was a big success with the critics, but I suppose those Back Bay and Beacon Hill people were still too stuffy and puritanical to buy any, except one flower painting, which Swetzoff said he could have sold forty times over. Ed went back to England, leaving the paintings behind because, without asking Ed's permission, Swetzoff had appliqued them to heavy cardboard, so they were unrollable, therefore untransportable by Ed, who of course would do nothing about getting them packed and shipped. Eventually Swetzoff was murdered or, let us say, found dead in the South End of Boston (nobody seems to know what really happened), and thus the gallery changed directors. It happened that in '66 we took a flat in Newbury Street very near the gallery. One day Conrad went in, saw the new director, asked about the Burra paintings, and to our astonishment, he still had them, and we managed to persuade him that we would care for them and see that they got back to Burra and Rye. So he kindly had them put into one package, and we had them brought to the flat where they safely remained until – after Conrad's long illness and death – I gave up the flat and had them sent to our house on Cape Cod. This was in '74. Finally they were shipped to Ed in care of the Lefevre Gallery, but by a horrible stroke of bad fortune, they didn't arrive before Ed's death, so he never saw them, only the photographs, which my daughter-in-law, Paddy Aiken, took of them when she and John stayed with me the summer before, which really delighted him, and for once he was looking forward to seeing his own paintings, which usually he appeared to ignore after they were finished.

Two other times Ed visited us in USA. Soon after we got our 'coldwater' flat in New York on 33rd Street between First and Second Avenues, alias 'doity thoid', a wonderful one room with alcove affair, where we even had a small piano and the WC in the hall was known as 'Fanny by gaslight', because it was sparsely lit by an old-fashioned gas flame, ostensibly to keep it from freezing, there being no other heat, and a large garden with seven ailanthus trees and a clothes line. It was during that winter there that Ed

again crossed the stormy Atlantic (cheaper off season) to New York, and a friend who had a house on 21st Street near Gramercy Park found him a room he could rent next door. So there we were together again with parties galore, and secondhand everything, books, furniture, etc, at our fingertips, and the best cheapest meat, vegetables, German, Italian, Yiddish shops, holes in the wall or outdoors *and* the best *fish*, Italian, French, even Philippino restaurants everywhere, likewise delicatessens and bakeries, and Irish bars, Catholic Churches, even the best hardware store I ever encountered, and the magnificent Morgan Library, and the Empire State Building with what Conrad called its rectal thermometer on top, lit up for the benefit of low flying copters or planes or migrating birds. We hadn't any idea what painting Ed was working on, because we never visited his quarters. He always came to us, where there was a cinema only a block away. He really had the time of his life, was well, and well fed the whole winter, and as he said, 'Never a dull moment!'

He returned to Rye in the spring when we went to Cape Cod, and then in September to Washington, DC for Conrad's job as Poetry Consultant to the Library of Congress. After two years of that we bought and renovated a house on South Capitol Street two blocks away from the Capitol and its dome which was our view from the front steps. Yum! Ed was again lured and this time he stayed with us where we had a well lit small bedroom big enough to hold him and his worktable too, so we didn't have to give up our dining-room table this time. Ed was painting some rather juicy flower pieces but our lives were hectic, although fun and funny, and fructified by the National and Freer Galleries, and Botanical Museum, all within walking distance for Ed. I fear there's nothing to paint in Washington, unless you feel like painting the whole town black. Good meat for cartoonists; too bad Daumier couldn't have had a fling at it. Anyway there was Herblock! We introduced Ed to Francis Biddle and his wife Katherine Garrison Chapin Biddle the poetess, who lived in Georgetown, and who knew and entertained 'everybody'. Francis was F. D. Roosevelt's Attorney-General and in charge of the American delegation to the Nuremberg Nazi Trials. His brother George was a painter whose wife Helene, a Belgian, was a very fine sculptress, so naturally, when they heard that Ed was a painter, they asked to see his work, and were so delighted with what he had brought from England with him, that they purchased a painting for their house on Cape Cod. Ed was really pleased, giving us all a good cause to celebrate. Soon afterwards, we put him on the train for New York and the Cunard docks for his return to Rye, and that was the last time he saw America, although we tried to lure him to Savannah, which he would have adored. He seemed simply not to have the energy for the complications of such a voyage, either by sea or air, alas! It saddened us when he wouldn't (or couldn't)

come even with Paddy and John Aiken to share the trip and help.

But, there was one trip earlier than the winter '38 trip to Charlestown when I first met Ed, which necessarily is hearsay from Conrad. In Rye, sometime in the early thirties, Ed had started illustrating some of Conrad's poems. He did a splendid one of 'John Deth', which he gave to Conrad, but which was put on exhibition at the Mayor Gallery, and presumably Ed forgot to tell them he'd given it to Conrad, and it was sold. I have seen reproductions, but I don't know who owns it now. Then he did at least two for 'Blues for Ruby Matrix', one of which I have, and was reproduced on the original cover of the Caedmon recording of Conrad reading the 'Ruby'. So at this time they were well acquainted, having been introduced by Paul Nash in 1931 after Paul had come to live in Rye. In consequence, when Conrad was in Boston, and Ed suddenly decided to come to America, he wrote Conrad telling him which ship and when it would dock in New York. Conrad had a feeling that Ed might be a bit addled by the speed and violence of New York, and although Ed hadn't said exactly what his plans were, he did say he'd like to go to Boston. Conrad decided to meet the ship at its New York dock. He found Ed in the Customs Shed, waiting his turn for inspection with one little suitcase and a roll of paintings under his arm. They exchanged greetings just as the inspector turned to Ed, and asked him to open his case. As Ed bent over, the neck of a pint bottle stuck out from his hip pocket. It being Prohibition then, and all hard liquor a no-no, the inspector tapped on the bottle with his pencil, clinkety-clink, at which Ed twisted his head over his shoulder, looked the inspector right in the eye and snarled, 'It's a growth!' That was the last seen of the inspector, who quickly departed for greener fields, and Conrad realized that he need never again worry about that young man, Burra, and to make it even clearer, suddenly a liveried chauffeur appeared, and inquired, 'Are you Mr Burra?' and Ed having said 'yes', the chauffeur picked up Ed's case, and the paintings, saying 'come with me, sir, I've been sent to fetch you,' and off they started with Conrad at a safe distance following behind, astonished and curious. The chauffeur found his limousine, opened the rear door for Ed where a handsome woman was lolling in a corner and whisked off to the north, Conrad having no idea where. So back to Boston he went. No more was heard from Ed, until about five weeks later he turned up at Pemberton Square, Boston, where Conrad was staying with a friend. He was quite green, said he hadn't seen daylight since he left the New York dock, and, guess who? It was Nancy Cunard who had snatched him off to Harlem where one presumes that adventure of all colours and kinds was the name of the game, and day and night one and the same. I haven't seen but one painting from the Harlem episode, and that a reproduction of a splendid one dated 1934 in the Cecil Higgins Water Colour Collection, but I

expect there are more. Doubtless Boston seemed tame, but still a good place in which to recover, and I think Conrad told me that he and Ed went back to England and Rye on the same ship in late '33 or early '34. Anyway, it all gave Ed a voracious appetite for the American Scene.

Which brings me back to Sir John Rothenstein's question and Conrad's answer. Almost immediately after Sir John returned to London in late '39 or '40, he went to Rye to meet Ed and see his paintings. He wasn't in the least bit disappointed, in fact he was so enthusiastic that he bought five or six. About that time the Penguin series of booklets on English painters was in the works. Sir John decided that he would like to write one about Edward Burra to go with the reproductions of Ed's paintings. This was a highly successful venture, not only for Ed, but all the other painters, edited by various writers and/or art critics. But the nicest thing for us is that the photograph of Burra, with which it leads off, is of Ed painting on our usurped dining-table in Charlestown, 17 Elwood Street, Boston, Massachusetts, where the little house still stands looking out to the Soldiers and Sailors Monument Square, and, from the dormer windows at the top, to the Bunker Hill Monument, the land his country found and conquered, lost, and won again by way of Burra, the English Artist.

A great deal more will be discovered about the deep relationship Ed discovered he had with the American scene, when Joseph Killorin, who is the editor of *The Selected Letters of Conrad Aiken*, and who is now writing the biography of Aiken, publishes also a complete collection of the Burra letters to Aiken and Aiken's to Burra, of which, fortunately a great many have been preserved. They are marvellously entertaining, apart from being informative. I hope Killorin will keep Ed's punctuation, which was nil, but somehow made them all the better!

Letters

written during the war by Edward Burra to William Chappell

June 1940. Springfield

Dear B. How are you bearing your cross? and where if I may be so bold as to ask.* We are still here. Camber and down there have been evacuated – all the week-enders fled from their caravan block houses with earth closet – but there were some old inhabitants – out they went losing everything in the way of potatoes and hens all going for no price at all the chickens – and arriving in Rye with no where to go all poor and no money – so enormous rents were then asked so I was told – . They would all prefer to be quietly bombed away among the potatoes and their own poor eggs (at the price they are) but oh dear no. Some natty officers came round here & were met by Madame Anne Huntley† who said *she* had no intention of going. So they said did she know what 'terrible things' would happen to her? if she stayd.

I believe I sold a picture from Matheison to the Tate and that double pic that was at Zwemmers. Aive not seen the colour of their money yet dear but you know we artistes live by beauty alone. Stephan Lorant Noel Coward and Madame Tabouis have all gone to the USA I see in the Times so write and let me know if you want anything. love E.

Springfield. July 4, 1940.

Dearest B. Thank you for yours. I'de been wondering about you. Let me know your address in Brighton & days off & we might meet. I dont suppose you can come here without a pass as this is *a devastated* area much improved in my opinion no monsters at all a veritable degringolade of people have left here enraging shop people & Popolo who are all very indignant. I dont think they can evacuate everybody from the South Coast. where are so many people to go in this right little tight little island? rather too *tight* it seems just now dear shall we be anchored in row boats off the Nore?

* Preston Barracks Brighton.
† Now Lady Ritchie.

Aug. ? 1940. Springfield.

Well dearie

Nous avons la grande scêne de Phédre followed by extracts from 'The dumb torturer of Barnstaple' at 8.30 onwards non stop till 8.30 the next day about 2–3 weeks ago bombs fell right on ye antiente towne flattening that nice pavilion with a bow window next ot Bensons house which was cracked Ye myrmayde received *quelque chose* on the roof that sent off all the tiles etc also 2 small houses vanished into dust to dust down on the road to Hastings. Mumsie is getting a shade nervous. I told her she should be 'grim and gay' thats what old Churchill said on the radio. Me dearie *ayme* very grim & gay. The night before last there was a terrific thump about 11.30 – that stirred them up dearie such a rushing up and down stairs ———— Such weather! I really feel quite dry and warm for a change and the beautiful nights *so* full of starlight and searchlight – mercifully there are no aunty aircraft guns round here so they dont all go off 'I dont care' like Eva Tanguey used to sing so sit in a shower of crashes reading my book annoying everyone I say why worry sweetheart if you dont die now your being 'saved up' for a dainty cancer death bed in the infirmary ward or cirrhosis of the liver later. ———— Ive become quite apathetic so long as I can get enough to eat & a bed to lie on Je m'en fiche môi' & General de Gallstone to you.

Oct 15, 1940. Springfield.

Well dearie

What a whirl of Messershmidt this evening they love it a little cloudy. About 8.15 as I was rounding the Velodrome Buffalo by the gate leading into the field. I heard a whistling bomb descending and held my head imagining I should be swept into the bamboo but it sounded about in the churchyard about a week ago 2 houses in the council housing estate were reduced to ruins and the backs of Prospect Terrace a regular prospect I was at the top of the hill and was reduced to crouching in the hedge. The lorry drivers fled like autumn leaves (falling early *this* year) & were all in hedges and ditches letting out a stream of fuck sod etc its a sort of British ave maria each sod a pearl, each fuck a prayer to twist a bugger by absence wrung. Len* has been photographing corpses laying in heaps in the Tube waiting to be swept away by a cholera I should say, do they use 'pots' dear? or shit on the track & cause a short circuit for toutes les waters are allways upstairs

* Len Lye.

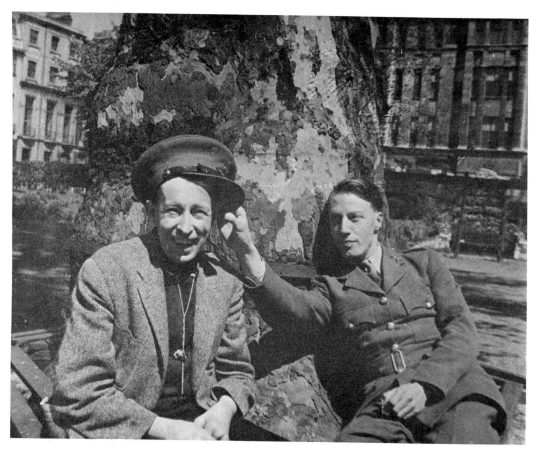

Edward Burra and 2nd Lt. William Chappell in Fitzroy Square, 1942

Nov 11, 1940. Springfield.

Dearest B. Fiendish did you say dear? I reach such a pitch of venom & spleen that I find myself falling back from myself. I think such wicked thoughts & fly in such black rages I fear sometimes I may meet 'somebody' when I go out of an evening to have a look at the barrage if any in the kitchen garden – The 35s are registering if you insist they can register me to their hearts content & the M.O. will have plenty tò 'feel' besides balls TEE HEE. I heard from Bum – in a hot waterless cave at great expense 37/38 St James Place What a bloody life we are all leading she says – the Ritz was straddled with Bombs and cocktails were shaken in drinkers hands – I thought cocktails were always *shaken*. – Shades of Harrison Ainsworth! The Tower has received something more than a cannonball. As for the Ballerines do you really suppose you'll hear from *them*!! They were billed at one spot as Miss Constance Lambert & 26 dancers ———— Anne came

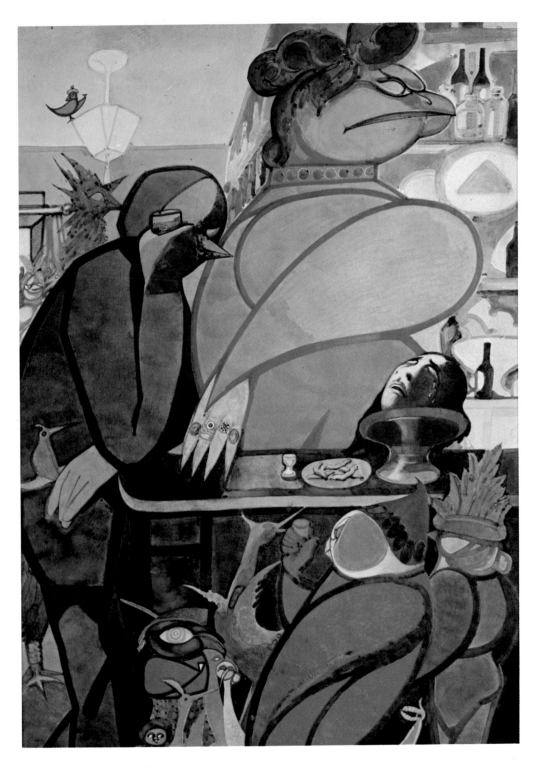

SALOME (1951/52)

back with a *Tatler & Bystander* the other day. I was dumbfounded smart N.Y. socialites The Bundles for Brittain Party —— Mdme de Creixa Pintoes Nusbaum de Peneranda Crucificado chatting with Bunthorne Quincey whilst stuffing a dolly with Patna Rice & Viscountess Castlerosse looking like I dont know what. Race meetings too ——— I.m hoping to go to the cinema & see Davis in *Elizabeth & Essex* I ve been looking forward to that since the trailer I saw – Davis, the colour of *Camembert* croulant (the only camembert we shall see in many a moon) peering into mirrors and hurling cups of posset at herself in disgust. I really enjoy that. The weather and scenery have never been more beautiful here.

Springfield. Nov 14, 1940.

I'm taking up my pen for Sundays venom, dearie, it relieves me. English meat very scarce at the meat market yesterday morning, the 35s call up I mean – I went to sign & found meat very scarce. all I saw was 3 men. I went over to Hastings dans le bus after the call up & found the usual state of decay – half Woolworths counters were closed 3 people and a quarter of mousetrap in Saintsburys & miles of boards I bought Shelleys works for 3d I like the Cenci – (purchase tax ½d) ——— the place is like a corpse —— Here of course is a paradise of quiet to some places tho its supposed to be a death trap & dead mans Gulch. I hope your not taken off by a lung complaint! Yrs Ed.

Nov 25, 1940. Springfield.

Cheeryho dear. bums up! Mother Corcoran graced us with a visit this weekend and left in a shower of chestnuts chives and eggs paper bags little boxes bags and I am sure she missed her train. Gerald still stewing at Aberystwyth: all the boys in the army seem to be looking *far* better Yes dearie it dont surprise me. Exercise fresh air & 'nothing' to drink would work wonders (& less to eat) A bomb blew up Pruniers so she says. well well we never thought when Grannie took us out to tea at Rumpelmayers (during the last war but 2) that the Louis 15 Y & Ladies orchestra would be metamorphosed into Pruniers and then blown up.

Nov 27, 1940. Springfield.

Well dearie how are you dreeing your weird? in pouring rain & a high S westerly gale. The only thing that ever stops aerial activity is a 90 mph gale I find ——— I see a squawk over no coal – they say theirs plenty at the pits & everyone is mad for it & they are putting off thousands of miners but

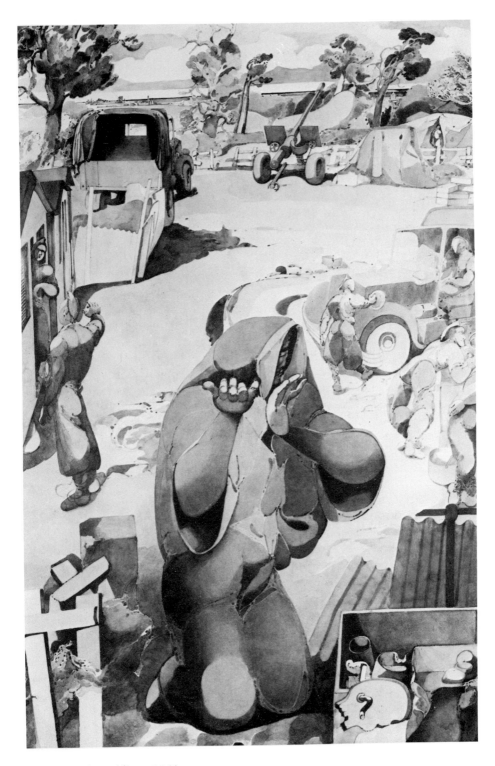

Death and the Soldiers, 1940

they cannot transport it & suggest army trucks should be used. You should see the army trucks here, my dear. Not *one step* do they ever walk. No wonder theres no transport. Its a miracle to me where all the petrol comes from. I should think they wash in it Its a pity you cant come & be a gunner somewhere down here there are enough in all conscience. Well dearie drop us a line yrs E –

Springfield, Dec 25, 1940.

Just some new years sick dear I m sending you. wrap your troubles in Milk Tray and Milk Tray your troubles away. —— I had a card from Fred of Welsh witches in an alms House! I ve never seen such a thing they go to Dartington Hall Totnes Devon for 3 weeks he says. I imagined them cowering at Crewe Station with a bit of artificial holly stuck in false plum pudding made of 3 ozs of ground carrot – I couldn't face Aberystwyth standing in the corridor etc* such fun – Tiggetty Boo standing well up —— I went to the old ruins again in the bus last Fri. starting in pitch darkness freezing cold you cant imagine what les environs de Lewisham looked like, somewhat gutted here and there & blackish grey! —— I dont know but every one seemed harassed to me – very nice and emptyish for just before Christmas I must say not that I went to a Dept store but les regions de Charing X I never can go anywhere else – I dont feel quayte at home. Well dear I can *scarcely* wish you a very happy new year – but the best we can do yrs. E.

Jan 1941. Springfield.

Your chapelet of gallstones arrived Having fallen down on the hill & being unable to bend I now have a septic toe which went mauve & caused me such agony it had to be slit & now of course I cant go out thank God as its covered in Epsom Salts and glycerine to draw out the poison & what hasnt it drawn out. If the food situation gets more difficile dear we shall yet see the storming of the barricades Yes – I may see Les Constance Lamberts boys when they open† Ime allways meaning to stay with Bum for a few days. I shall carry on a little study in the purlieus of a morning – I ve got quite a lot of paper (if it isn't blown up) Vermilion water colour has suddenly risen to 3/6 a tube as its used to rub gun barrels! Lechertier Barbe tells me. Cadmium red 2/– & all the other colours havent gone up at all & brushes – I ve layd in a little stock as 'Oh we cant get any more russian sable' they say.

* To visit Gerald Corcoran.
† Sadlers Wells Ballet at New Theatre.

CORNISH LANDSCAPE, NEAR ZENNOR (1975)

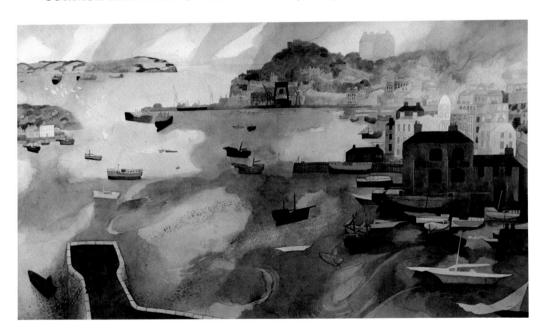

THE HARBOUR, FALMOUTH (1975)

Lechertier Barbe* is a very good shop & not a penny more expensive I always thought it was but its not and is very conveniently situated. Bryce Smith & Hampstead Road is too far for me nowadays. I revolve on my visits on an axis of Brewer St Windmill – Trocadero – Charing X Rd bomb crater. Ernest Hemingway has got out a new one I see in my US papers called *The Bell Tolls* deeply moving dear about the dear old Span civil guerre. He ought to be here oughtnt he Ayme sure the Ritz Bar would be 'deeply moving' I'me told the cocktails mix of themselves. What I should like is *Pal Joey* by John O'Hara about a sub Bing Crosby broadway night club crooner 'Just a heel.' it sounds hideous to me. I know I should love it it would deeply move me. We shall never be allowd that Ime sure All the publishers seem to have been blown up from what I see in the papers. It seems a little warmer. And give me your address if you move. Ime glad you got the chocolates very rare dear. milk – Yrs E.

*No longer there.

The Other Story

WILLIAM CHAPPELL

THE MOVE – in 1969, a year after his mother died* – from Chapel House in Rye to 2 Springfield Cottages, a few steps down the road from his old home Springfield, changed completely Edward's way of living. The family, once so compact a unit, had disintegrated like a cobweb, leaving Edward and Anne, surrounded by cousin after cousin after cousin. To me the country-side round Rye is mostly populated by the cousins and the in-laws of the Burras. I do not know and have never attempted to find out the exact numbers of the regiment. Edward became, at the age of sixty-four, an independent householder for the first time in his life. He had never lived alone. Now he was master of his own meal times. His own caterer. His own cook. The proper achievement of this state was – to be realistic – due to the vigilance, the tact and the care of his sister; acting as chauffeur, nurse, gardener and close companion, she made it possible for him to organize his life as he wished.

He settled, as though inevitably, into a solid domesticity; and discovered (regardless of his usual and perpetual mild eccentricities) an absolute order – beneath an apparent chaos – in his daily life. There were the regular working hours. The times for resting. The times to be taken to do the shopping. The times for preparing food. This had become, outside his painting, a dominating interest. His skills in the kitchen had grown steadily and his assurance and his culinary repertoire were increasing all the time. He studied cookery books with the same care he had taken when teaching himself Spanish. Tante Marie was a Delphic oracle. Eliza Acton and Elizabeth David minor prophets. He was addicted to the cookery writers in the newspapers, particularly Sheila Hutchings (*Daily Express*) and Delia Smith ('Very clear and practical, my dear.') in the *Evening Standard*.

Edward descended on London at regular intervals, possibly every three weeks or so. He would stay two nights with Barbara Ker-Seymer, or with Gerald and Phyl Corcoran. In between I would go and stay with him. When I telephoned to ask if I might visit the reaction was immediate. 'What shall

*His father died in 1958

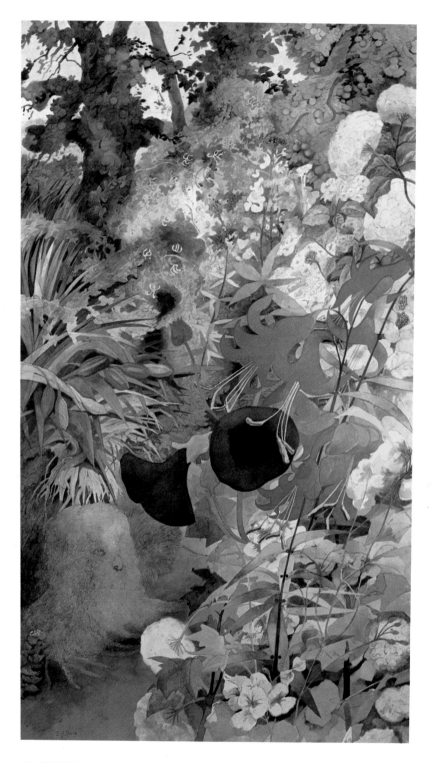

FLOWERS IN A LANDSCAPE (1975)

we have? I could go to Peasmarsh and get a decent shoulder; or a tongue? Would you prefer fish? I saw very good skate in the fishmonger's this morning.'

When we were not engrossed in discussing the merits of the latest volume about a fantasy fiction character, Conan the Barbarian, to whom we were both addicted, we swapped recipes, and ways of interpreting them, interminably. We crowed or lamented over our successes or failures; compared the country prices with London. Our housekeeping conversations resembled those between Mrs Tabitha Twitchitt* and her circle.

Any time left empty from painting Edward spent in the kitchen. It became his living room, his sitting-room, his dining-room. And, as a tidal river overrunning its banks, it poured surplus matter into the real sitting-room next door, leaving many unsuitable objects under a splendid Regency side table – baskets of withering apples; an enormous lidded pottery jar (used to hold bread); several large biscuit tins – one exceedingly rusty – filled with mysterious odds and ends including lumps of fairly ancient cheese. The actual surface of the table received (to its detriment) the overflow of Edward's shopping in the shape of the tins, jars, bottles and packets that could find no inch of space on the kitchen table.

Everything in 2 Springfield Cottages overflowed and intermingled with everything else. A sea of clothing, old and new, slid into the sitting-room, part of it edging into the tiny lobby inside the front door, where the hooks on the wall were already three deep in coat hangers – each draped with garments.

The sitting-room – deep vermilion walls, dark bright blue curtains, shining white paint – would have been a nice sitting-room had there been anywhere to sit. The seats of each one of the comfortable armchairs where I longed to loll (rather than perch on a heap of catalogues and copies of *Private Eye*, making an unyielding cushion for the chair facing Ed's at the kitchen table) were obliterated and possessed by high bulked heaps of clothing. There were jackets, slacks, caps, overcoats and the end results of Edward's own laundering: shirts, sweaters, vests, T-shirts and underpants; cleaner, no doubt, but also magnificently crumpled as they were never ironed. Edward loved clothes. A dandy when young – as may be seen in photographs; one in Fauntleroy velvet and lace; another (at hated school) in stunning Eton suit with broad white collar, and waistcoat elegantly slung by gold watch chain. Later in life he made sudden excursions to London to visit the more reputable stores – Simpson's in Piccadilly, Aquascutum in Regent Street – emerging triumphant bearing a very smart, very

*Beatrix Potter's frugal and housewifely cat.

expensive sports jacket or an impeccably tailored blazer with glittering brass buttons. Could there be – I sometimes wondered – a deeply entrenched Tory person struggling to emerge through his crumpled tartan shirts, bulky rib-knit sweaters and unpressed corduroys? If there were it never got out.

He seemed in good spirits, though there were days when his pallor was more pronounced and he was quieter than usual. It was clear his arthritic limbs, his tender feet, were causing him pain. He did not complain. I very rarely heard him complain. His work had long ago proved to be the most efficient pain killer. He devoted all his passion and the greater part of his day to it. The concentration demanded (by the act of painting) from his imagination and the whole of his mental being, temporarily crowded out physical discomfort.

Several times a year Anne arranged to take him on short motor tours to see the incredibly various aspects of the landscape in Great Britain. They went to Yorkshire, Derbyshire, to the Lake District, the West Country and Cornwall. When I was able to, I went with them. It fascinated me to watch Edward when the car halted by some especially splendid spread of hills, moorland, and deep valleys. He sat very still and his face appeared completely impassive. He might, I thought, have been staring at a blank wall, until I saw the intensity of his gaze.

I do not remember Edward ever making any sort of note: not even the faintest scribble; yet weeks, even months later, the shapes, the tones; the actual atmosphere; and the colour of the clouded skies looming above those moors, hills, and valleys he had looked at so intently, would appear on paper. I am convinced he possessed a unique mental capacity (wholly denied to most people) to absorb, and *never forget*, any images he truly observed.

He appeared (between bouts of feeling less well) content with his way of living and mostly in fairly high spirits; until, following a weekend visit to London, a short time after five o'clock in the afternoon when he was due to be met at Rye station by Anne, Ed melted into limbo. Expected anywhere, he had always been punctilious about arriving. Anne, distracted, having met in vain the two trains following the one he should have been on, rang Barbara Ker-Seymer, who rang me. We were deeply uneasy, and received little comfort from the information, laconically relayed an hour later from St Thomas's Hospital that Edward had been brought into Casualty and had given them Barbara's telephone number. I suppose I shall never forget finding him when we arrived at the hospital at about 8.30 that evening. It

Opposite *The owl mentioned on page 29, painted in about 1957*

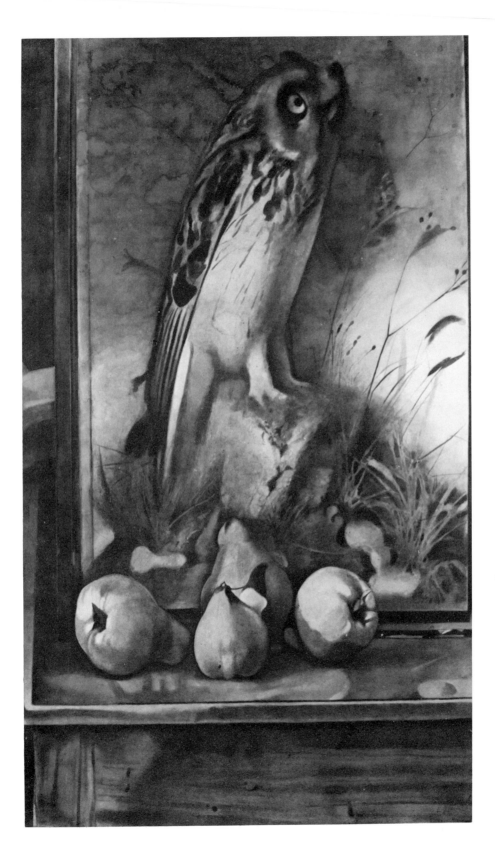

was coming up towards 'prime' time in Casualty, and surrounded as he was by the wounded, the broken and the desperate, he did not look completely out of place. He was wearing a cotton hospital shift tied with tapes, and staring with guarded hostility from a tilted stretcher bed stuck in a corner: his face incredibly wan, his hair standing up every which way, his bony arms tangled over his head (a favourite posture when horizontal, strangely reminiscent of an Odalisque by Ingres), one forearm scored by a long raking cut with drying blood streaked about its edges, and a mauve lump the size of a hen's egg just above one eye.

Shaking with mixed emotions – relief at finding him; terror at finding him in such circumstances – we burst into hysterical jabbering. 'For Heaven's sake, Ed! What *have* you been doing? *Why* didn't you make them ring before? They said you have been here since four-thirty.'

Ed's baleful expression told us we were guilty of what was to him the unforgivable crime of 'Making a Fuss'. His reply was not only a flat statement of fact. It was delivered with deliberate complacency. 'I was dead *drunk*,' he said.

Sure enough, a postscript to a docket hanging above him, detailing his condition, his bruises, etcetera, informed anyone who cared to read, 'The patient said he was drunk at the time of the accident.'

'I'm quite a novelty here, dear' Ed continued sourly. 'And if one more doctor is brought along to examine my *remarkable* spleen I shall start shouting. Now, will you get me out of here.'

The only answer to this request was to find Geoffrey Dove. Splendid, unflappable Geoffrey Dove, who was not only a close friend of Ed's, but also a good and wise doctor. We found him and he arrived in twenty minutes, calm as milk. 'Don't touch that man,' he said firmly to a hovering doctor. A young nurse standing a few feet away looked round. It was abundantly clear from her expression she regarded each one of us with suspicion. She was in the middle of counting what turned out to be one thousand and nine hundred pounds in twenty pound notes which Edward had been carrying in his inside breast pocket. She found quite incomprehensible – and who could blame her – the connection between the money, the heavy gold chain round Ed's neck, and the battered plastic carrier bag to which he had obviously clung as though it contained the Koh-i-noor. Its actual contents, we discovered later, were two pounds of scrag end of lamb purchased from the butcher near Raymond's Revue Bar; and intended for an Irish stew. Our deprecatory mumbling 'You do realize he is a most distinguished artist . . .' died away before their icily polite smiles; and glancing unhappily at him it had to be admitted the bag of scrag was the most relevant part of his property when considered in the light of his wild appearance. He looked as though he had come off the worst in a

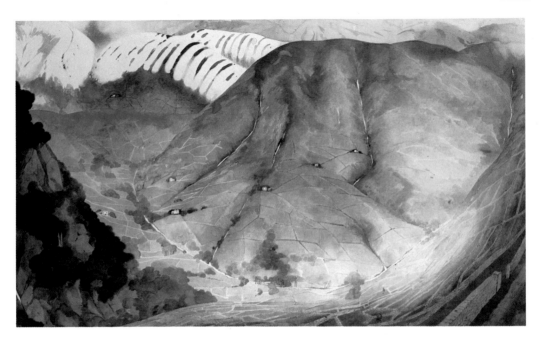

LAKE DISTRICT LANDSCAPE (1973)

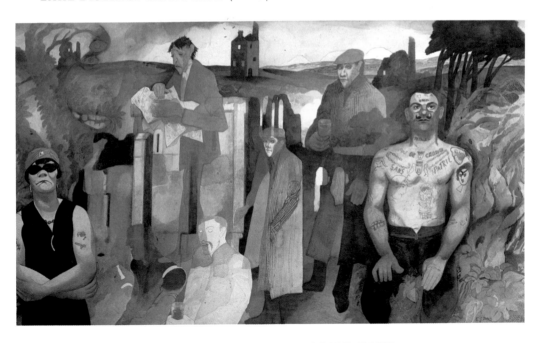

FIGURES AND TIN MINE: CORNISH LANDSCAPE (1975)

wino's fisticuffs in some derelict basement.

Following him from St Thomas's to the hospital in Lambeth where – to his absolute rage – he had to spend a statutory night, we were ordered to attend to the safety of the scrag end. Entirely thanks to Geoffrey Dove we were allowed to remove him from Lambeth the following day; and after one night in London, Anne took him to her house in Rye from where he was soon resettled in his own home.

I did not know – nor did I ever find out – the truth about Ed's accident. Drunk he certainly was. Down with a wallop he had certainly gone. Run over and killed he could certainly have been; weaving his way towards Charing Cross to catch the three-thirty train. Whether he fell or tripped or was caught by the wing of a car or a taxi, and who summoned an ambulance I never knew. I did not, in fact, want to know. He appeared to make a recovery; and it was a few weeks before I could bring myself to accept that the horrid tumble marked the commencement of a slow undermining of his resilience and his self-reliance.

Sitting opposite him, passing the whisky bottle back and forth over the heaped plateau of the kitchen table (which he had turned into a perfect replica of his work-room floor), I noticed his face seemed smaller – paler. Not actually marked, but as though its outline had been redrawn by a slightly shaky hand. After two or three whiskies, the faintest pink glow appeared on his cheekbones and the extreme tip of his delicate nose.

The visits to London became fewer and far less energetic. He seemed relieved rather than resentful (as one had known him before) at the close watch his friends kept on his comings and goings. He was met at the station and taken to the homeward train again at the end of his visit. I would catch sight of him when I went to meet him and see him moving (as slowly and as deliberately as a snail) among the trailing figures of the last passengers to alight; a duffle bag hung over his shoulder. I felt a surge of affection as I watched him approach so slowly and painfully, and we embraced when he passed the barrier (who are those two dotty old men kissing each other? they must be foreigners).

Taking his bag, offering my arm to lean on as we meandered towards a favourite pub, he muttered into my ear, 'I'd never have made it this morning if I hadn't had two very large whiskies.' It was of course willpower as much as whisky: a good medical mixture and it was the willpower portion of the prescription that finally got him where he wanted to go.

He was painting a great deal at this time; and had been intensely prolific ever since he moved into his own home. Much has been said and written about the various painters who had influenced his work. These influences (strong in their day) had long been absorbed. No trace of them remained. In the later paintings the influences – if any – are purely literary – echoes of

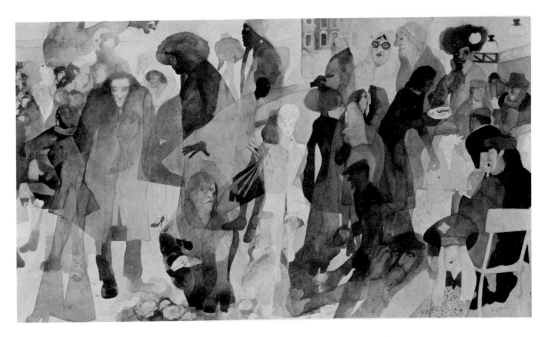

Figure composition, 1974: 'Don't you find as you get older, you start seeing through everything?'

images from favourite writers. These are traceable through a knowledge of the extent and variety of his reading. Having this knowledge the clues are there, and it becomes possible to recognize the brooding giants (Gods? – or Forces of Evil?) squatting on the peaks of the wild hills. The drivers' cabs of the sabre-toothed lorries coasting the high moorland roads hardly bear scrutiny, for the drivers are chilling 'presences' rather than men. Then there are the figures seen through each other, in landscapes seen through the figures, painted in thin washes of pale colour. 'Why,' I asked stupidly, 'are you painting transparent people?' 'Well,' he replied logically. 'Don't you find as you get older, you start seeing through everything?'

Flattered he may have been at the prospect of his retrospective exhibition at the Tate Gallery in 1973; privately he thought it too much and too late. He was amenable as long as he could make it clear he had no intention of taking any part in it. He did not appear at the private view. He never went to any of his private views. He regarded painting as too private for those noisy public gatherings. He never allowed a picture by himself to be hung in any house he lived in. His mother was driven to a secret purchase of one of his paintings. She was permitted to hang it in her bedroom. Nowhere else. He had no conceit about his work. It was something he did because he had to.

'I have nothing to say about Fart,' he is said to have replied to a person

asking serious questions relating to his artistic philosophy. Whether the remark be apocryphal or not, the word – meaning an ejection of superfluous air, sometimes ill smelling – sums up his views neatly. As far as he was concerned Art was too serious to be serious about.

So, life at the start of nineteen-seventy-six was satisfactory – almost enjoyable, until his second accident in the late spring. Leaving a shop with an unnaturally high door step down to the pavement in Rye High Street, he stumbled. No rail to catch or to help the effort of the deep step down, he could only crash to the paving stones. Anne had let him out of the car minutes before; at almost the same time I was leaving the train at Rye Station. Ten minutes later I was sitting in the office of a firm of builders in Cinque Ports Street (having called there on my way to a lunch time rendezvous with Edward), when cousin Frankie Broderick arrived with the news of the accident. Ed was on his way to hospital in Hastings. Anne had followed the ambulance. I followed Anne in a taxi, my stomach knotted with dread.

We met in one of those hospital waiting rooms where everyone automatically assumes the personality of a stranded refugee. Our faces, wiped expressionless by terror at the thought of an operation on so bloodless, defenceless a body, we stared at each other as though we were strangers.

The operation* took place. Against all hope and all belief he survived.

His recovery was slow and difficult and excessively painful. He went from the hospital to a convalescent home, and from there to pass a further convalescence in the house of Anne and Colin Ritchie.

He was not the easiest of guests. He needed, and longed passionately, to be in his own home. He fretted dreadfully to be back at his work, the major point of his way of living. It was impossible he could be alone until able to walk again. He had now spent weeks without so much as seeing a paint brush. This was the most wretched deprivation. He hated the steel frame within which he had to learn to walk. He hated the pain any movement produced. In spite of this he made certain of some sort of rehabilitation. He spent odd days, accompanied, at the cottage, trying to find his way about. The table and the chairs in the kitchen were moved to give him something to cling to on his way to the cooker. This stubborn determination to conquer the weakness of his sorely tried body found him, eventually, fully in residence; sitting, still and concentrated, at his work table. He produced splendid recordings of the blinding-burning summer of nineteen-seventy-six; but for me there is little doubt the efforts he made to reinstate himself within a life he had found so eminently satisfactory, proved too demanding.

*Mending a broken hip

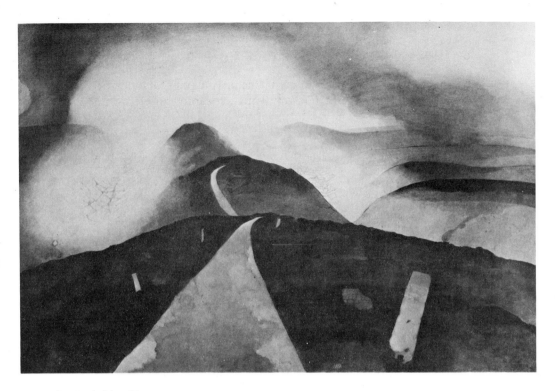

The Yorkshire Moors

At the dead end of August I spent my last weekend with him. Everything appeared more or less as usual until on Sunday he excused himself and retired to bed. Later, I heard him vomiting in the bathroom. Over-respectful (as we had always been) of each other's privacy I waited until I knew he was back in bed before I ventured into his room. He was on the bed; ashen faced, fully dressed, looking drained of all energy. I enquired tentatively if he wanted something to drink. He refused saying he felt terribly sick. I brought him a bowl and retired to the kitchen; later, to my room.

Neither of us slept. I lay listening. He vomited on and off all night. No ordinary sickness; only dark, stinking water. I would take the bowl, empty it, rinse it and return it to him. Towards daylight he slept a little; I was thoroughly alarmed by the time Anne arrived.

'He's very unwell,' I said, and told her about the sickness. I returned to my work in London full of forebodings. When I rang that evening Anne told me he had been taken to the hospital. I never saw him again. He said to her one day as she sat by his bed: 'I am dying, you know.' A few days later Colin telephoned me to say he had gone.

Edward's friends (with most of whom he corresponded regularly) were

strung out across the world. Many of them did not know each other. He tended to keep them in separate compartments. I think each one of us satisfied different things in his character. One emotion was common to us all. A devotion, spontaneous and deep. He had a uniquely attractive personality. Strangers took to him on sight and his immaculate manners rarely allowed him to show the irritation and boredom he often suffered. At his most shaky, physically, I never knew him not to struggle to his feet to greet a guest.

His death set up a strange reverberation (akin to the rubbing of a wet finger on the perimeter of a glass) ringing throughout the circle of those who knew him. Admiring and respecting his remarkable gifts as a painter, we loved him as a person. His indomitable spirit, his idiosyncratic humour, his fundamental kindness, made us love him and dote on him. Doting is, I suppose, a finally more comprehensive form of affection than blind all-embracing love, because of its fond appreciation of the quirks and foibles in the personality of the dotee.

I have laughed longer and deeper and more enjoyably with Edward when he was in good spirits than with anyone else I have ever known.

POSTSCRIPT

It had always been clear to me that Edward's friends were important to him. How important I did not fully realize until some weeks after his death, I went with Barbara to help Anne in the formidable and saddening task of sorting out the great unwieldy mass of books and papers to which he had clung with such tenacity throughout his life.

At the time of his removal to Springfield Cottages he wrote to Conrad Aiken, '. . . what with all this packing up I really did think I was loseing my mind and I knew, *if I gave up, nothing I wanted would ever reach here* . . .' (The italics are mine.)

Removing layer after layer from the rich archaelogical dig on his work-room floor, we found the major part of those slopes of stained and dusty papers consisted of the letters of his friends. It both touched and comforted me to know he had set such store by these recordings of his life and our lives which went back into the early nineteen-twenties, and to discover he had taken such care to remove them (some almost illegible) from house to house. And where, in those houses he made his place of work – the place where he was most uniquely himself – he had laid them down and around, and beneath him, so he sat painting above a positive island of affection.